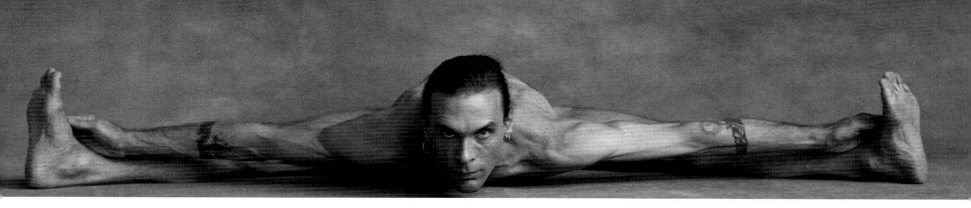

THE ART OF YOGA

SHARON GANNON and DAVID LIFE

PHOTOGRAPHS BY MARTIN BRADING

Foreword by Anoushka and Ravi Shankar

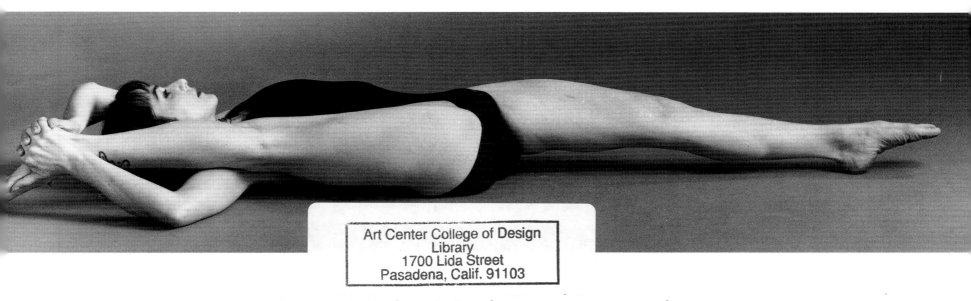

stewart, tabori & chang · new york

Published by
Stewart, Tabori & Chang
A Company of La Martinière Groupe
115 West 18th Street
New York, NY 10011

Export Sales to all countries except Canada, France, and French-speaking Switzerland:
Thames and Hudson Ltd.
181A High Holborn
London WC1V 7QX
England

Canadian Distribution:
Canadian Manda Group
One Atlantic Avenue, Suite 105
Toronto, Ontario M6K 3E7
Canada

Library of Congress Cataloging-in-Publication Data

Gannon, Sharon.
 The art of yoga / by Sharon Gannon and David Life;
 photographs by Martin Brading.
 p. cm.
 ISBN 1-58479-207-8
 1. Yoga, Hatha—Pictorial works. 2. Yoga—Pictorial works. I. Life, David. II. Title.
 RA781.7 .G355 2002
 613.7'046--dc21
 2002021169

EDITED BY Marisa Bulzone and Elaine Schiebel
DESIGNED BY Nina Barnett
GRAPHIC PRODUCTION BY Pamela Schechter and Kim Tyner

The text of this book was composed in Frutiger

Printed in Italy by Arti Grafiche Amilcare Pizzi

10 9 8 7 6 5 4 3 2 1

First Printing

Dedicated to the Divine Mother

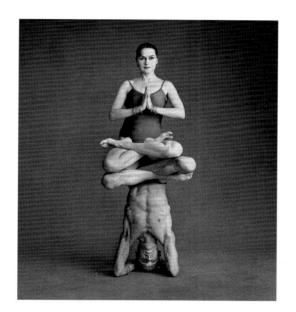

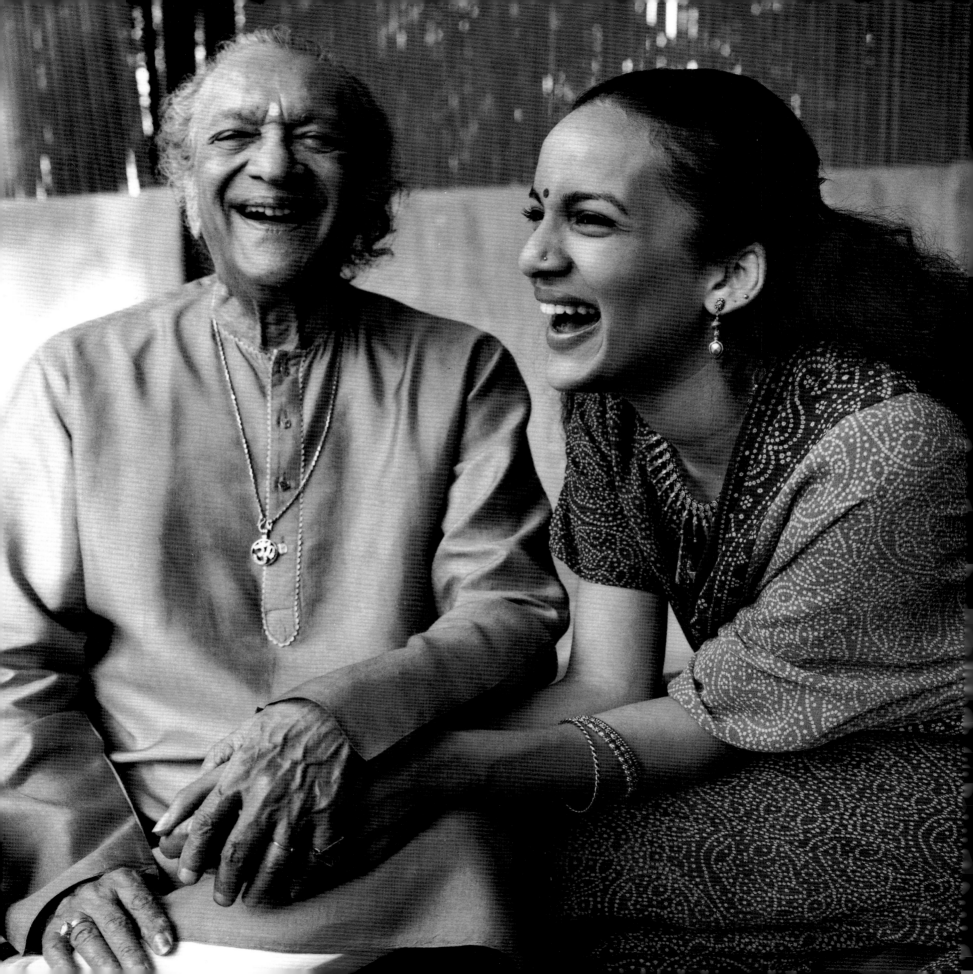

Foreword

To me, YOGA signifies four things: Y for *Yukti* (reasoning), O for *Om* (the primordial sacred sound), G for *Gnyan* (wisdom), and A for *Agni* (fire or power). I am also a worshiper of *Nada Yoga,* which incorporates music in the attainment of yoga. There are two principal *Nadas: Anahata Nada* and *Ahata Nada. Anahata Nada* is the cosmic unstruck sound heard by great yogis when they are blessed with the highest enlightenment and *mukti* (liberation), after years of meditation and *sadhana* (dedication) under a guru's training. But as a mere mortal, under the direction of my guru, I have pursued *Ahata Nada.*

The *Ahata Nada,* or struck sound, is the search for divinity and godliness through music. There have always been two types of musicians: One is a professional showman and entertainer; another, who, though a professional performer, also believes that music is a meditation and prayer with which to reach God. This latter type of musician believes in *Nada Yoga* and also the ultimate phrase *Nada Brahma* which means "sound is God."

As an Indian, I feel proud and honored that all the different forms of yoga thousands of years old have been respected and adapted in all the different parts of the world, and that the physical, mental, and spiritual benefits have been admitted by all.

Reading books on Hatha Yoga, Bhakti Yoga, and other forms of yoga can definitely provide lots of knowledge to sincere seekers. But I firmly believe that "book knowledge" is not enough as far as yoga is concerned. The same sincere seeker has to learn personally from an experienced, enlightened, and adept yogi.

In this grim period of worldwide violence, terrorism, pollution, hatred, war, hunger, and disease, it is heartening to see that there are some conscientious people who are trying their best to bring relief and comfort to others through philanthropy, art, literature, music, dance, and yoga.

Yoga, with its many different approaches, can definitely be a great help in building a healthy body and mind and in elevating one to a higher spiritual consciousness. Thanks to teachers like Sharon Gannon and David Life, yoga has been accepted on a serious level in the United States and not just as a fad. What pleases me is that it is not just restricted to older people. Interest has spread among the younger generations also.

As a devotee of the muse, I practice *Nada Yoga* and suggest that all yoga students listen to less of the pounding, rhythmic music and more to soothing Indian chants or Sistine Chapel hymns, church music, Bach, Hayden, or any kind of soft, slow lyrical music of voice, harp, harpsichord, or flute.

In the past, the seers who were great yogis and gurus steered their *shishyas* (disciples), according to their merit and tendency, to different paths of mental and physical yoga, such as Raja Yoga, Bhakti Yoga, Hatha Yoga, *naam siddhi* (the chanting of divine names such as Rama, Shiva or Hare Krishna), *mantra siddhi* (the spiritual power given to you by chanting mantra), *chakra bedha siddhi* (to awaken the Kundalini), and the whole cult of Tantra (which gradually became more popular). But unfortunately, instead of one proper and adept guru we find today hundreds of quacks and half-baked gurus all over the world making quick money teaching all forms of yoga, including the popular Karma Yoga and Tantric sexuality.

I do believe that today with the advancement of technology, the human mind, and science, one has to preserve traditional art and techniques of music, dance, and yoga with a new approach. We cannot go back to the system of hermitage in the forest or ashram living. This illustrated book defines "yoga" as a beautiful art form instead of presenting it as a technical manual.

I commend Sharon Gannon and David Life for taking the right approach and helping so many people into the sacred domain of YOGA!

—Ravi Shankar

The last thing I want to do through writing a foreword along with my father for this book is to claim to be any kind of expert on matters of yoga. Of course, I wish I were, but sadly, that is not the case! For a long while I didn't really understand why Sharon Gannon and David Life would want me to be involved and kept warning them, "But I don't really do yoga, you know!" In reply they said, "That's not the point. You connect to that state through your music, plus, after seeing your father's views on the subject, we would also like readers to get a contrasting, younger opinion."

How silly of me. Of course, as I've been brought up knowing my whole life, music is also a form of yoga and of meditation. As my father wrote, as musicians we try to follow Ahata Nada, or the search for divinity through music. In both yoga and Indian classical music, one needs the guidance of a true guru to put one on the right path. There is an intense relationship between the guru and the *shishya* (disciple) as, in a one-to-one relationship, the guru dispenses his knowledge about the art form. The student must practice diligently to absorb his guru's training and perfect his technique. And finally, after much study and dedication, the student must be on his own, to grow and discover the spirit by himself.

In my life, my father has been that guru. Since the time I was about seven or eight, I have been studying under him, first very casually, of course, then as I grew older and more in love with our music, more and more seriously. It has been the most incredible experience to be so close to someone as inspiring and spiritual as he is, and to attempt to learn from him the nuances of his skill, virtuosity, and heart-aching beauty. Compared to him I am absolutely a beginner in the world of music, but already it has brought so much to my life, not just in the sense of glamour or exotic travel, but more so. It's moving, spiritual quality has always affected me and probably has made me a better person on the whole.

People have always asked me, either in interviews or in conversation, how I manage to juggle such different aspects of my life (modern lifestyle, ancient tradition) without going crazy. The truth is I need the diversity; it keeps me whole, it keeps me sane. Without music and what it has brought to my life, growing up, I might not ever have been involved in anything deeper than shopping or flirting with boys. I feel so grateful that I was brought up with a knowledge (also greatly thanks to my mother) of karma, spirituality, and a deeper purpose to life. Otherwise, who knows how long it would have taken me to find it? George Harrison once said to me that if he hadn't met my father and been introduced to Indian music, yoga, and philosophy as a young man, it could have been "eternities until he stopped chasing his tail around and found any kind of true purpose."

In a way I feel that's true of many young people in the West. Kids are brought up to get good grades in school, do well in sports, graduate, get into a good college, get a degree, get a job, marry, have children, and on and on. . . but how many decades before they finally turn inward? The few younger people I meet in America who are seriously involved in yoga or meditation are always set apart by a certain air, a kind of quiet confidence or purpose. Sometimes yoga becomes quite fashionable and then quite a lot of teenagers and young adults affect a knowledgeable attitude about it, but I don't see many who are genuinely involved or dedicated to it. It is a deep hope of mine that through this book and other means, more young people will become interested in a deeper way, because they will gain so much in their lives through it. There is no reason to wait until one is older to begin paying attention to the spirit.

Through Martin Brading's gorgeous photography, the intricacies and details of each yoga position are wonderfully conveyed in this book. In working with him, I was reminded of the fact that, like music, any type of art can be a form of yoga. He was so easy to work with and so at one with his camera, and in seeing more of his photographs, I realized how much of his spirit was poured into his work.

Meeting Sharon Gannon and David Life was a similarly beautiful experience. I was immediately struck by their childlike openness, their love of life, and the deep spiritual quality running through them both. In talking to them, I was shocked to hear that at the beginning, when they first started teaching, they were strongly discouraged from alienating the Western students with such "unnecessary things as Sanskrit chanting or too much talk about spirituality!" In many ways yoga in the West has been reduced to a way of burning calories and shaping the body, so it is truly wonderful that people like Sharon and David have been true to the heart of yoga and managed to bring that spirituality out in so many people.

Though I'm sure reading this book is nothing compared to studying with them in person, it is a breathtaking, thorough beginning point for the serious student and simply a lavish and beautiful possession for either the expert or the curious reader. I am sure this book can continue the wonderful work they have done in bringing the true benefits of yoga to all.

—Anoushka Shankar

Photographer's Statement

When I lived in London during the 1980s I shared a studio with a photographer who had hung a large print he'd taken for an advertising campaign. It was a black-and-white shot of a woman in a contorted yoga position with both her feet behind her head; yet she was looking straight at the camera with a serene expression of peace and contentment. Her image—which was going to be used to sell something like life insurance or tinned peaches—has remained fixed in my mind because of what she radiated from her beautiful face.

I felt that same sense of ease in Sharon and David when we shot the photographs that comprise this book. I first studied with them ten years ago and the experience has been transforming my life ever since. Sharon and David have made yoga practice and study their lives' work and in every class they illustrate their belief that ancient wisdom has an artful form and a sublime quality for both practitioner and spectator.

As a photographer I saw a wonderful opportunity to record their experiments. The images that we see by choice or proximity affect our lives in ways we often don't acknowledge so it is important to choose wisely what you do look at—when you have the choice. The human form has preoccupied artists since people first learned to draw. Whether portrayed in the form of Krishna, or painted as an intimate portrait, the body always reveals some profound truth. The human form in a yogic posture expresses a primordial aspect of existence and praises and rejoices God's handiwork.

It might seem ironic to try and photograph people in yoga postures since yoga is an inward journey and yogis go inside themselves to reconnect with the Source. However, David and Sharon tell the story of one of their teachers who would tell them to pretend that they were at a photo session with God. "You know, God is always looking." Sharon and David are graceful, because they allow grace to come through them. The project turned into a rewarding collaboration where I wasn't just recording their poses, but creating a series of portraits of them exploring the yoga asanas. Together, we wanted to elevate to an art, the commonly held perception of yoga.

Yoga is not about putting your foot behind your head. But then again, if you could do that, still breathe smoothly, and have that relaxed look on your face of the harmony of the body and soul, then that might be something worth a thousand words or more.

—Martin Brading

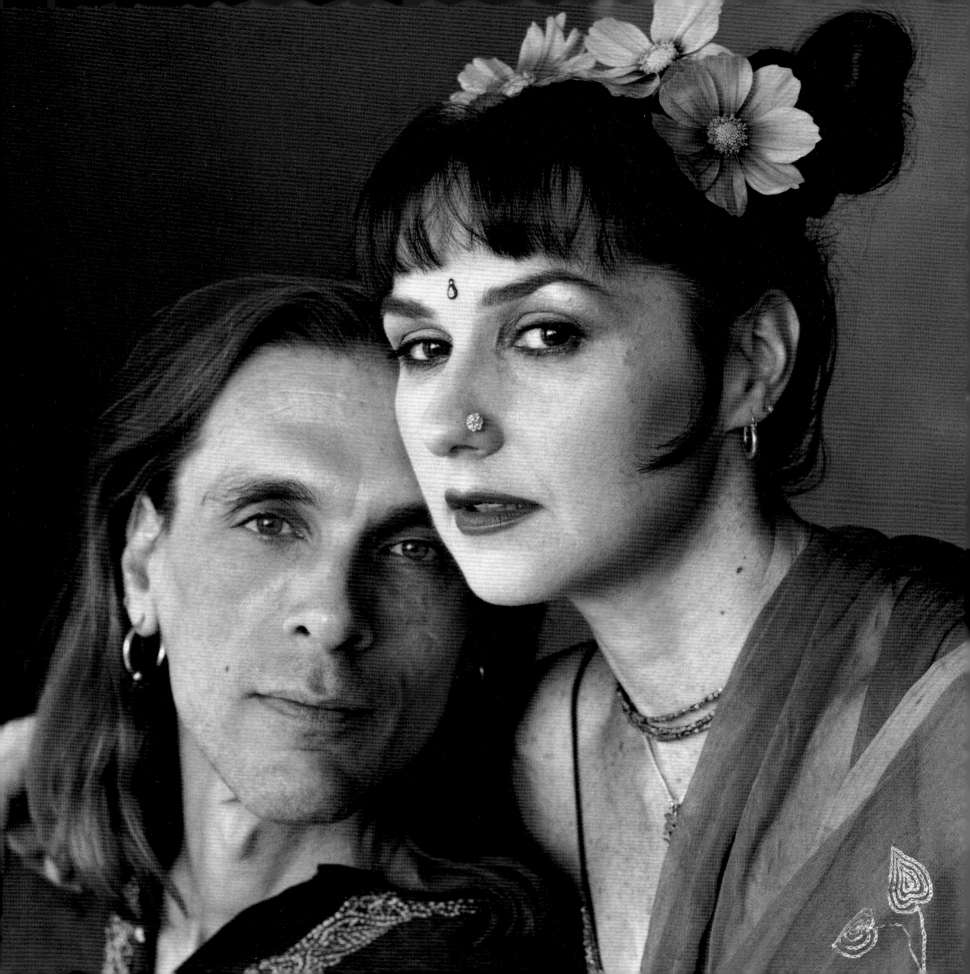

Introduction

Are we more than the sights and sounds of our culture?

The ancient philosophy of yoga tells us yes; there is an eternal, ever-present reality within us that transcends the limits that society imposes on us. Art has always been a celebration, and thus a verification of that eternal reality. The highest art is timeless, universal, and not restricted to the culture that created it. Music is the first art. Everything—all that is manifest—proceeds from sound. The ancient seers, the rishis, gave this teaching and modern physics has verified it.

The aim of Hatha Yoga is to realize sound as the source of creation. This realization is possible only after a harmony with the earth and all things manifest is achieved by the yogi. This book is a collection of photographs of yoga asanas. Asanas are commonly thought of as only the physical poses that yogis practice. The Sanskrit term asana means "seat," or connection to the earth. Earth is all of manifest creation. This definition of earth includes the air, water, soil, plants, and all species of animals. The perfection of yoga asana, or the art of yoga asana, is the perfection of one's relationship with all beings and things. A harmony can be achieved that resounds from the yogi as sublime music and touches everyone, and reminds them or uplifts them toward the spiritual source of All.

The ancient Sanskrit scriptures tells us that joy is the nature of God and that joy is at the core of every living being and thing. The art of life is to uncover this joy. The art of yoga is to trace your way back to this eternal fountain of joy. Without kindness and compassion toward all other beings and things, this path back to the source is all but impossible. Art must express joy as life's final aim. Underlying even the most melancholy of love songs is a sweet longing to reunite with the source.

Art is an experience. The word art also encompasses the techniques and tools used by the artist to evoke an experience. But art is much more than technique. Art is also a way of life and a way of looking at things—or a philosophy. The word yoga is used in somewhat the same way. It refers to an ineffable goal and the tools and techniques used to attain it. We say we are going to "make art" in much the same way that we say we are going to "do yoga." Art is a celebration of life and materiality; it uses the substance of life to channel a fresh experience from the universal soul. Yoga uses the medium of life to access the ineffable source of being. It is a practice that uses mundane experience as a doorway to transcendental realms. Art leads us to the universal in physical materials like musical instruments, the human body, paint, fabrics, paper, clay or metal. Observe this circular relationship:

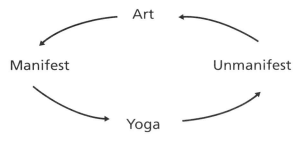

Art teaches us how to see aspects of divinity in the world around us, while yoga teaches how to use the world around us to return to our source. Art teaches that there is truth in each moment of existence. Yoga teaches that through truth ultimate existence can be experienced. Art creates and nourishes, while yoga nourishes and releases. Together art and yoga form a complete circle from individual self to Cosmic Self and from Cosmic Self to individual self. The real art of yoga is to transport ourselves into previously unperceived realms of luminosity and then conduct that luminosity into our earthly existence.

In India the line between art and yoga has always been very fine. Dance, sculpture, literature, music, and drama all incorporate yogic forms and stem from the same roots. Asanas are appreciated in various arts. In fact, the originator of yoga is said to be the God Shiva who is also the Lord of Dance. *The Art of Yoga* serves to make this connection apparent to a Western audience as well.

We are often bombarded with images of war and predictions of earthly destruction, including the reality of the extinction of species. Contemplating the fate of the earth can lead to disturbing thoughts, which in turn promote feelings of helplessness, sadness, and remorse. But we as individuals are empowered to change the fate of the world by changing our relationship with the world. Only through an artistic, musical harmony with the others that share the planet can this be achieved. As a celebration of nature and our potential, art provides us with insight and inspiration. Art should uplift the beholder and add a new dimension to our lives. Art should uplift the soul, expanding awareness and consciousness.

Yoga is a portable art form, free from costly equipment and supplies. All it requires is a sense of adventure and a willingness to explore the vastness of the Self. Our culture has become saturated with the desire to acquire skills, power, and material things. Unfortunately, the arts have become commodified, but the Self cannot be commodified. You cannot hold onto it nor can you buy or sell it. It exists in every being and is available at any time.

The earliest illustrations of asanas were painted, drawn, or carved on ancient temple walls. Yoga photography, however, has a short history consisting of primarily technical illustrations or exotica. Early photos appearing in yoga instruction books were amateurish and naïve. But occasionally an asana would be photographed with an artistic flair, revealing the glow of the skin and the classic form of the body. Here we have tried to preserve the simplicity of presentation. As yoga has been popularized in the West, photography has played an increasingly important role exposing it to an expanding audience.

Martin Brading's photographs have captured the essence of form and tone, which distinguish each asana as an art. Perhaps these images will rekindle a deeply buried memory inside your own being where joy, harmony, and serenity prevail.

—Sharon Gannon and David Life

Tasya Vācakaḥ Praṇavaḥ
Yoga Sūtra I.27

God is OM

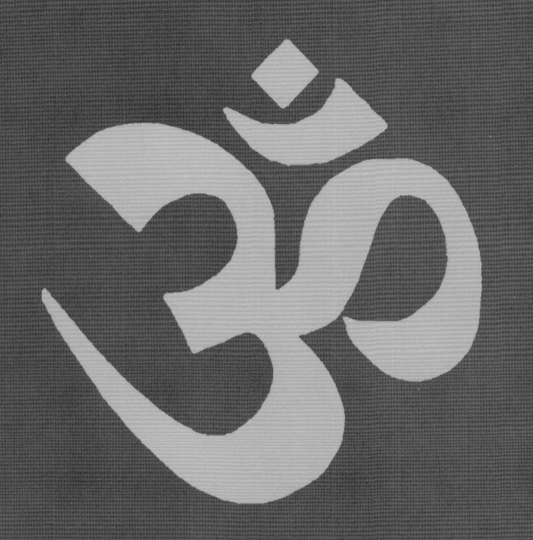

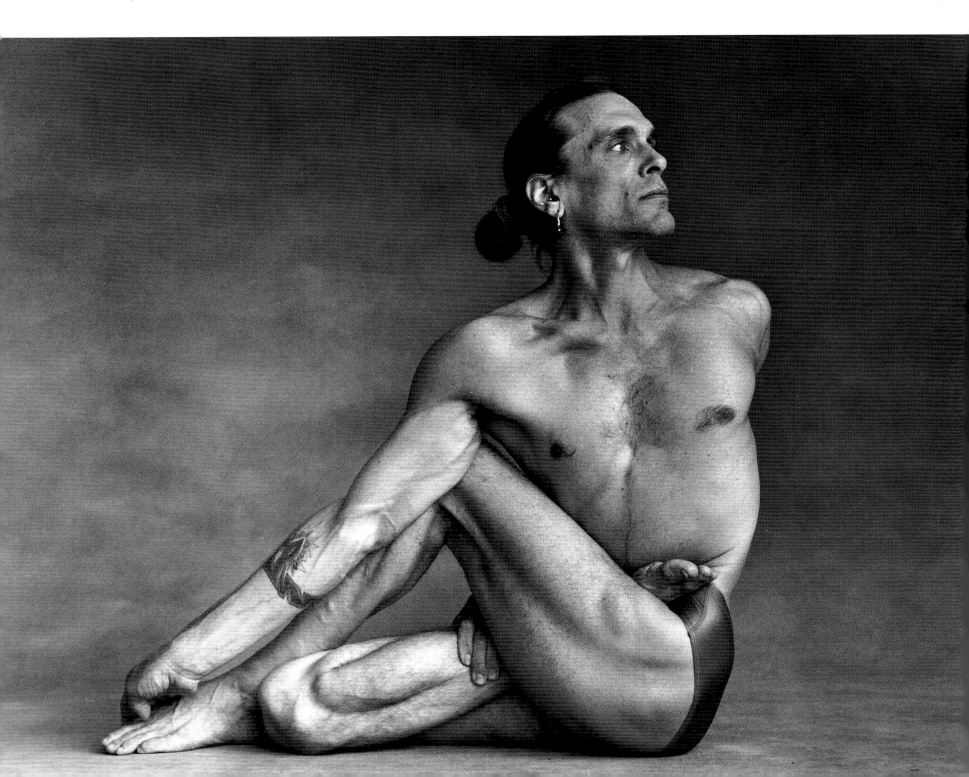

In the practices of yoga our resistance to the natural state of bliss and our attachment to the world of forms and senses is made apparent. When we feel limitation in the body or the mind, it is an opportunity to concentrate on our true nature, which is love itself, beyond limitation.

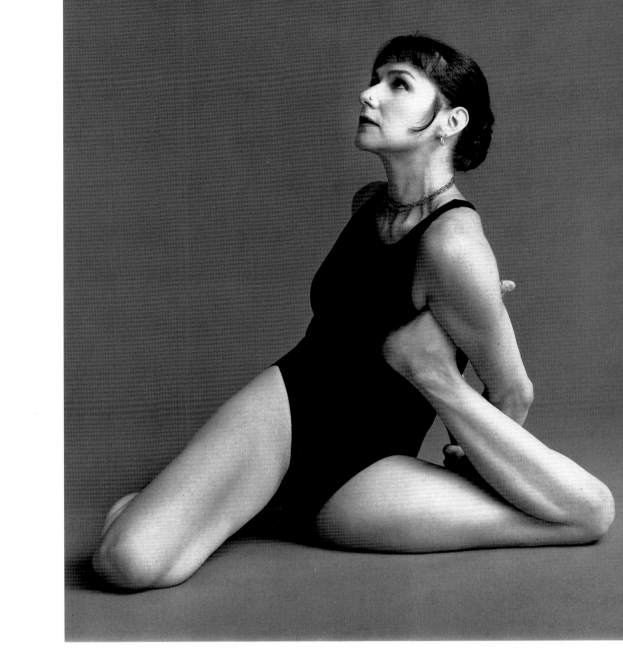

Yoga Daṇḍāsana

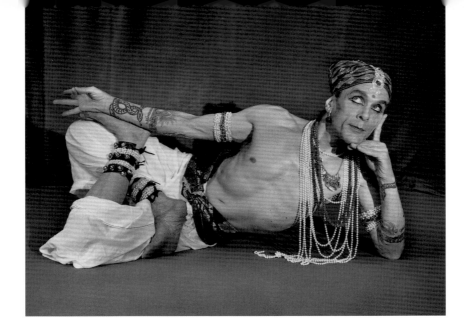

Yoga is who you really are.

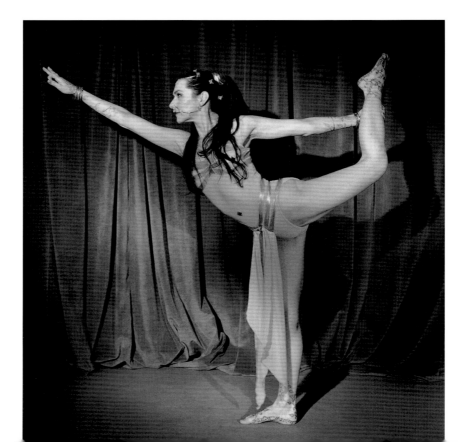

Art does not imitate life, but rather expresses the common essence, which runs through all of life.

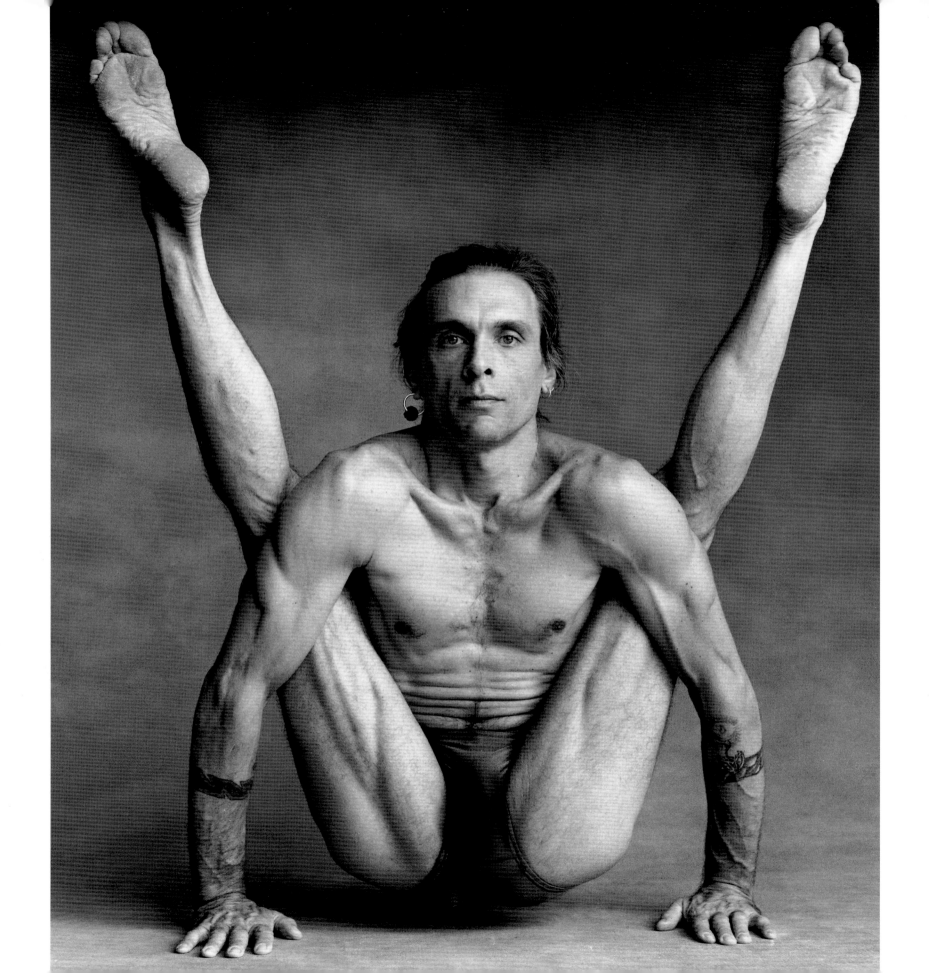

There are perhaps as many asanas as the total number of life forms, which may well be infinite. So how is one to master all of the potential movements or fluctuations? By knowing Oneness, the many are known simultaneously.

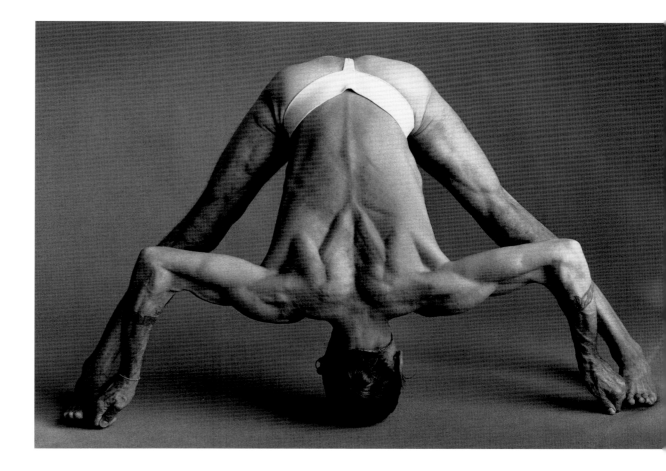

Prasārita Pādottānāsana

When one points a finger at the moon,
gaze at the moon, not the finger.

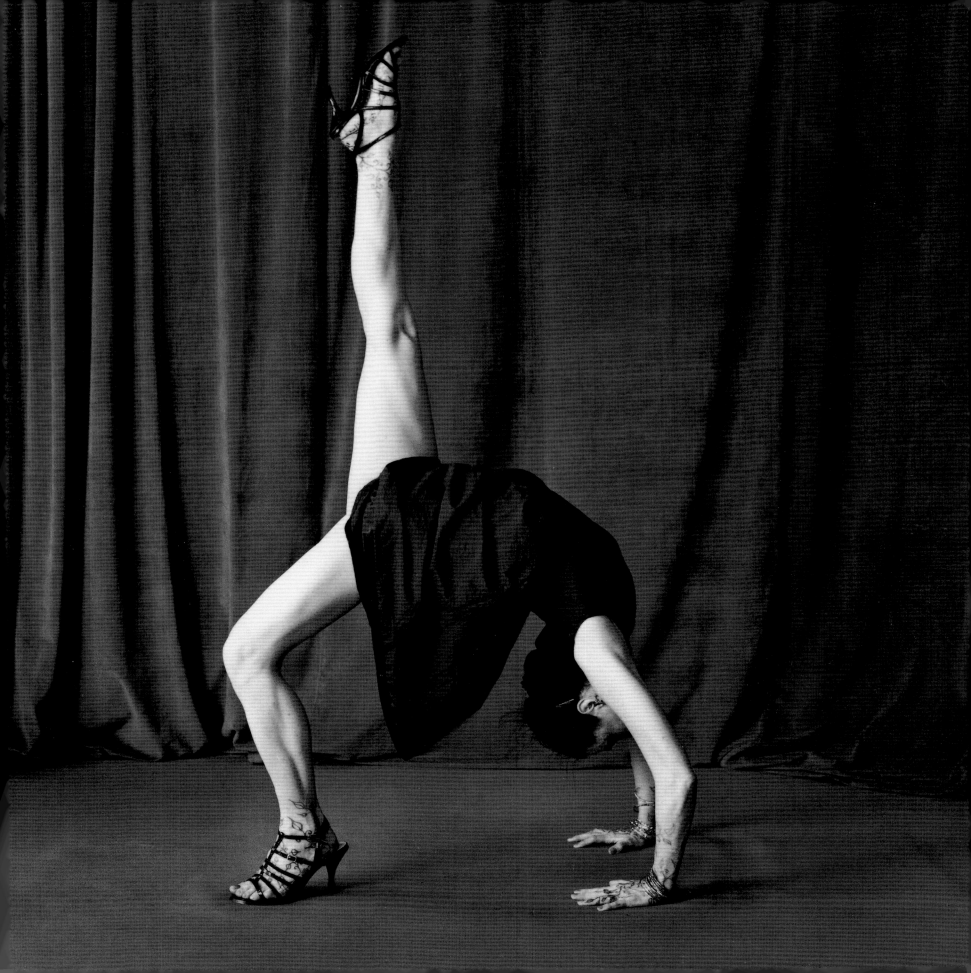

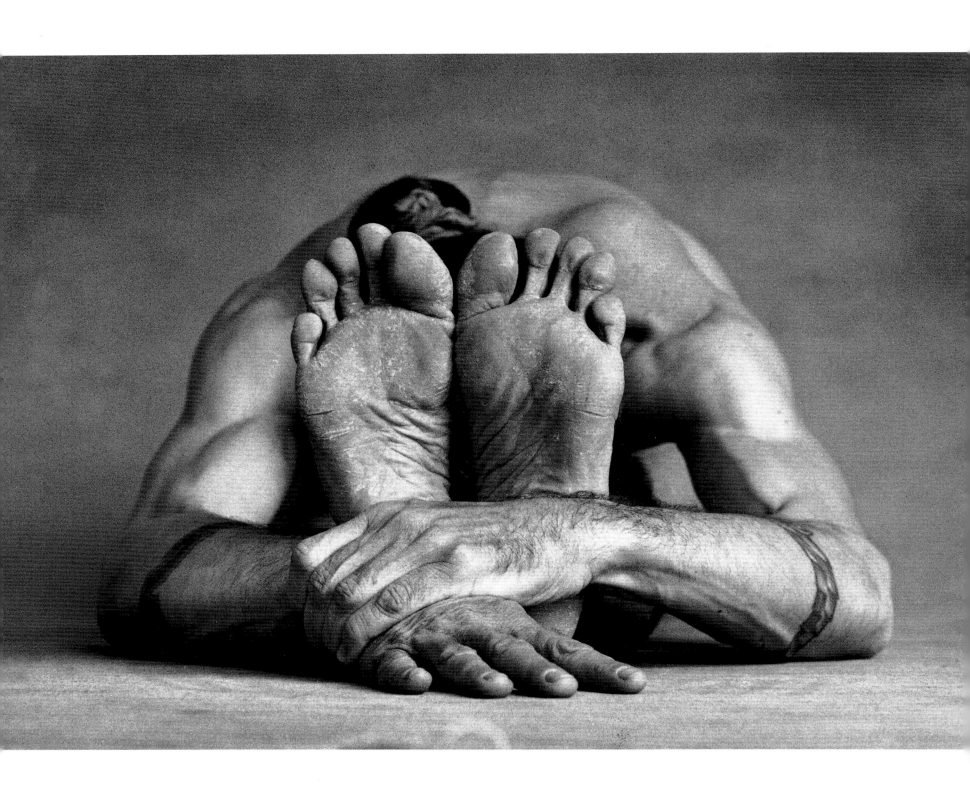

In the molecules of a body, we see the same fundamental structures and relationships observed in the universe. The atoms of your body are bundles of energy orbiting other bundles of energy. It is possible to experience a deep understanding of the universe when we expand our insightful personal experiences into cosmic proportions.

Our challenge is to remain upright and graceful despite the forces of entropy, faithlessness, and greed—not in an attempt to change the world, rather to create an internal environment that has a peaceful and beneficial affect on our state of mind. When there is equanimity of mind, the affect on the world around us is profound.

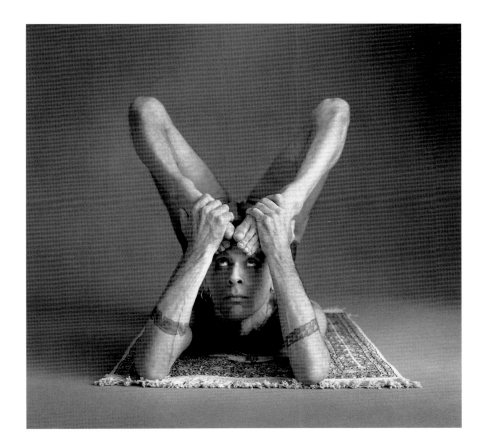

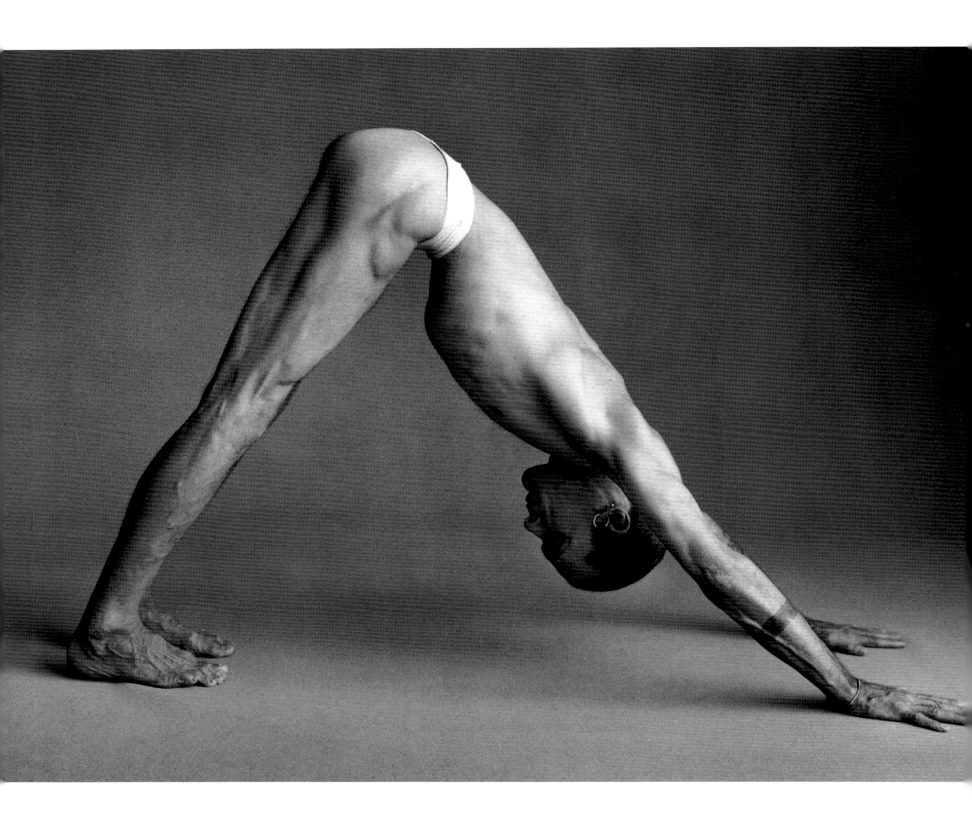

Adho Mukha Śvānāsana
DOWNWARD-FACING DOG

We compare our bodies to shapes and patterns in nature, in order to understand and have a relationship with something that appears "other" than us. We relate to everything through experiences we have in our bodies. Having new experiences is our primary way to learn. We learn about love by falling in love. To overcome otherness we must learn to see the essence of the Self in others.

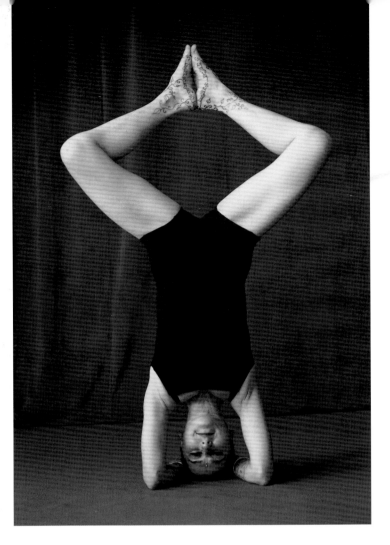

The key to finding happiness in your own life is to do all you can to uplift the lives of others.

Garbha Pindāsana

BABY IN THE WOMB

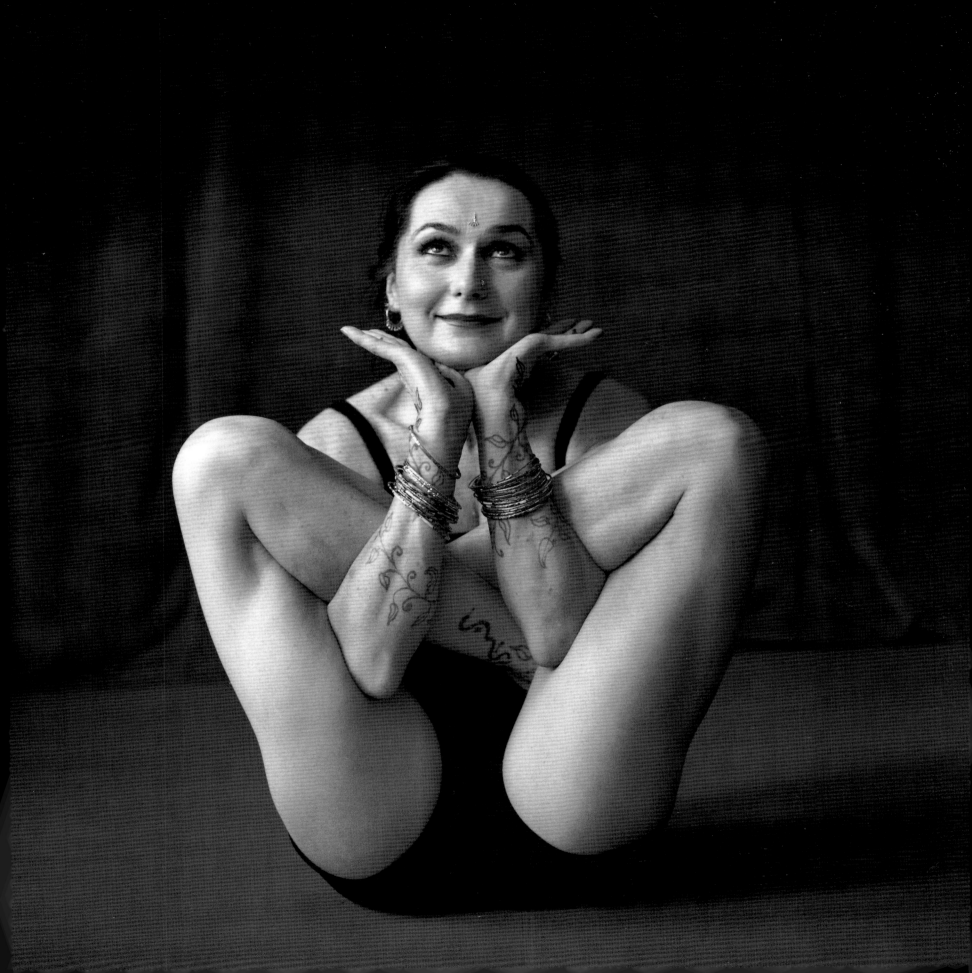

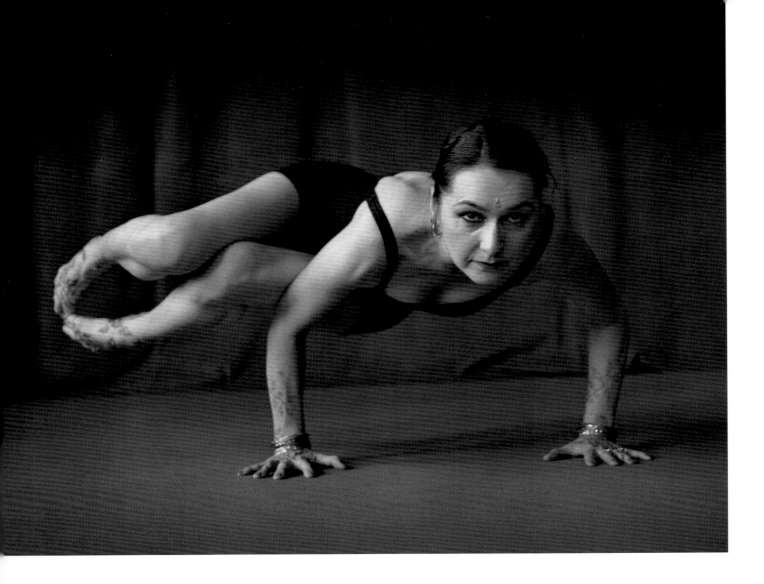

If you try to hold your balance you will lose it. Balance is attained by reaching for it.

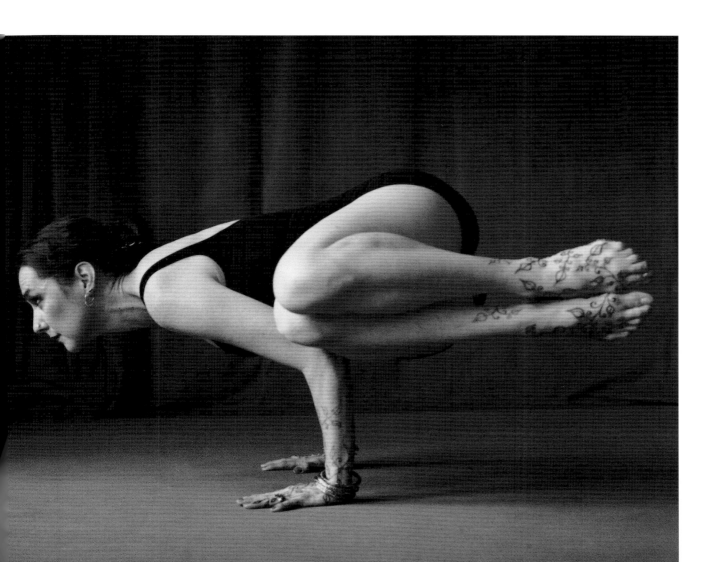

If you are not steady and happy in an asana, you have

not perfected that asana. The moment of completion

is like a star on a cloudy night, first appearing then

hiding. The wise astronomer stays his impatience with

wonder and ease.

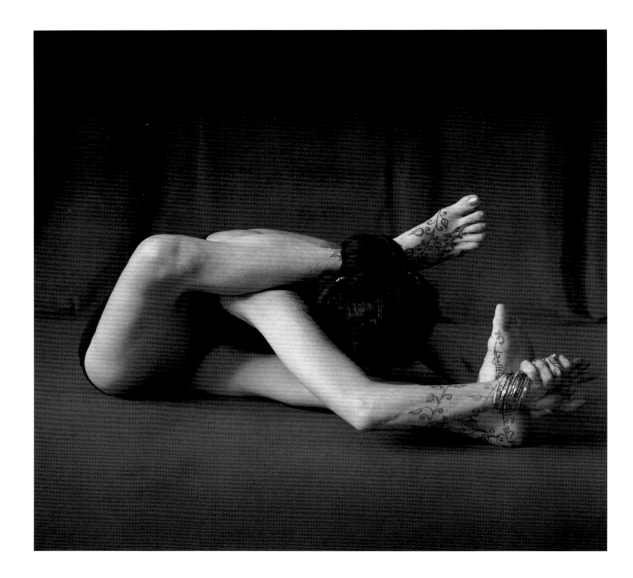

Yoga philosophy tells us that we cannot change our past, but future suffering can be avoided. By doing your best not to cause suffering to others now, you will avoid suffering in your future.

Through repetition the magic will be forced to rise.

— Alchemical precept

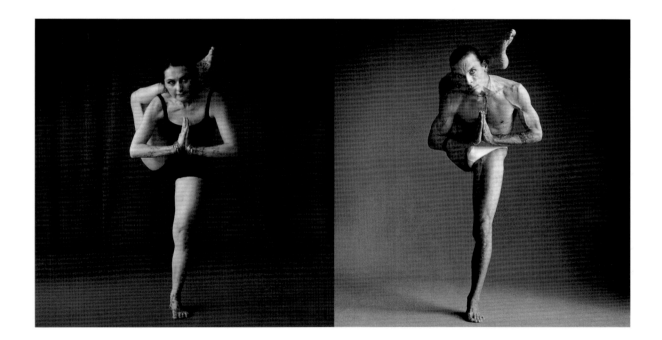

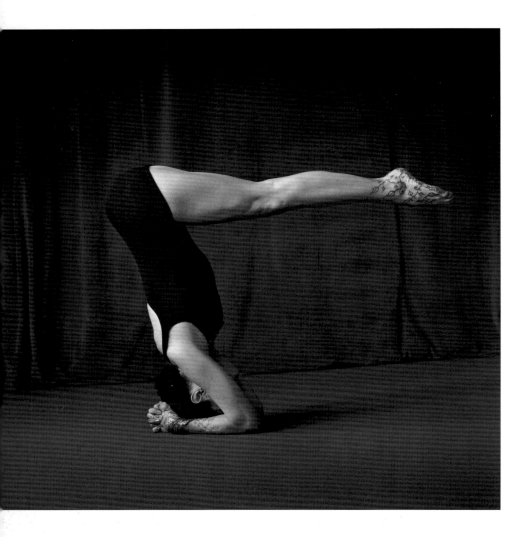

When there is confusion in the mind, there is confusion in the body.

When there is clarity in the body, there is clarity in the mind.

Eka Pāda Setu Bandha Sarvāngāsana

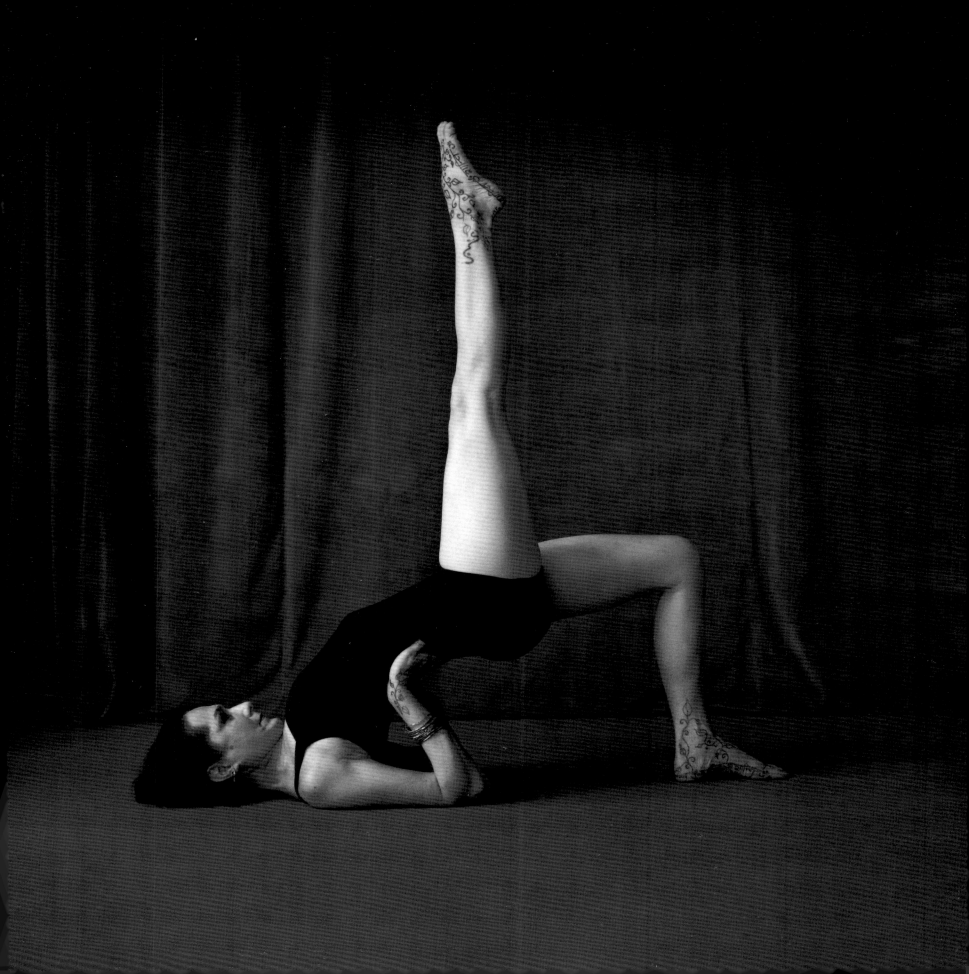

Śīrṣāsana

HEADSTAND

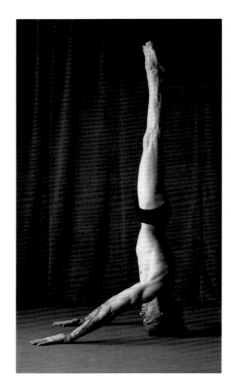 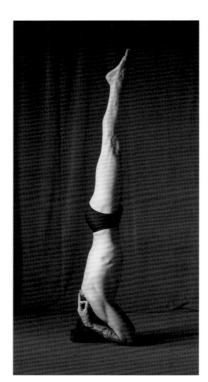 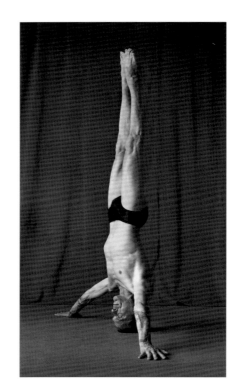

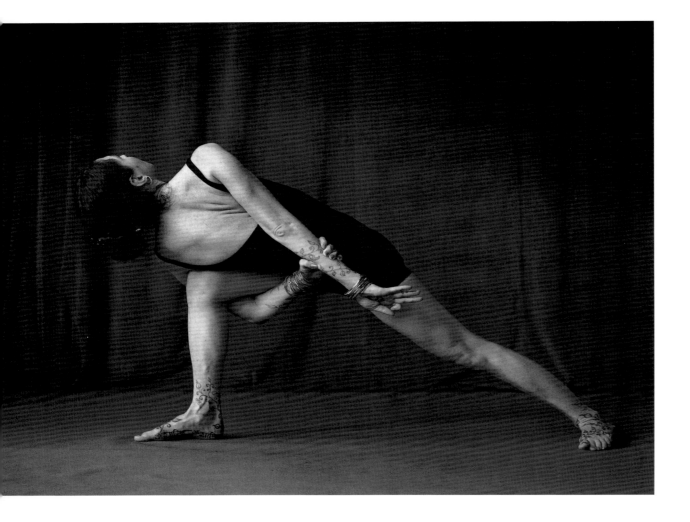

When we extend our physical body while intending to extend our hearts, we awaken our own innate generosity from within. This intention of giving permeates every cell and tissue.

Utthita Pārśvakoṇāsana

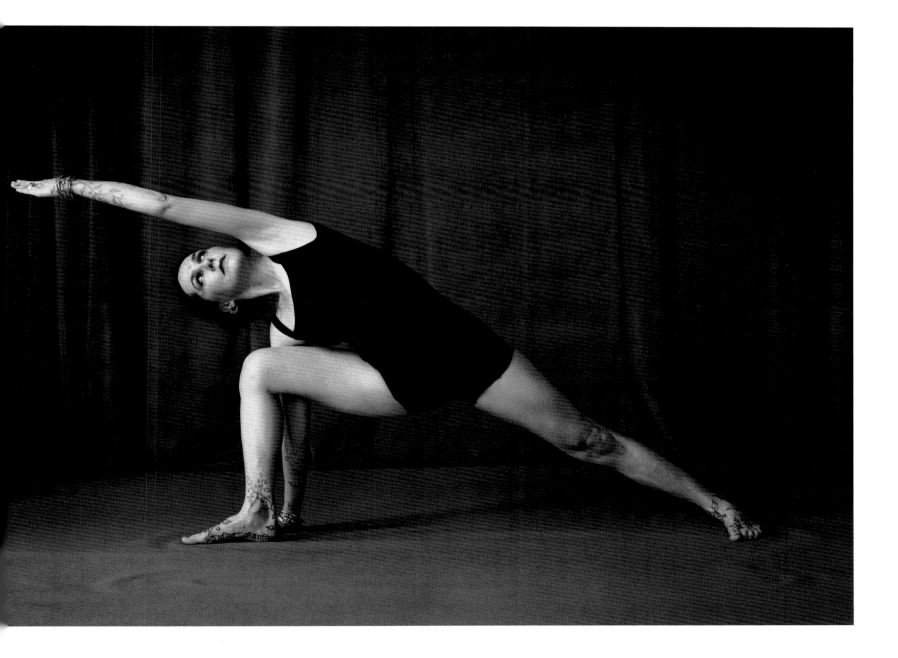

The Sanskrit word *asana* means seat. Seat means connection to the earth. Earth means all beings and all things. The practice of asana is the practice of refining your connection to the earth.

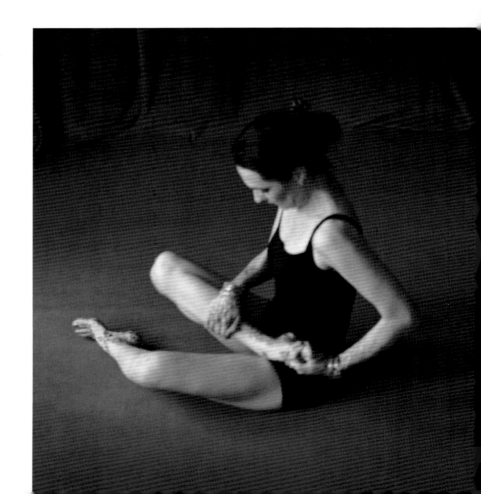

Baddha Padmāsana
BOUND LOTUS

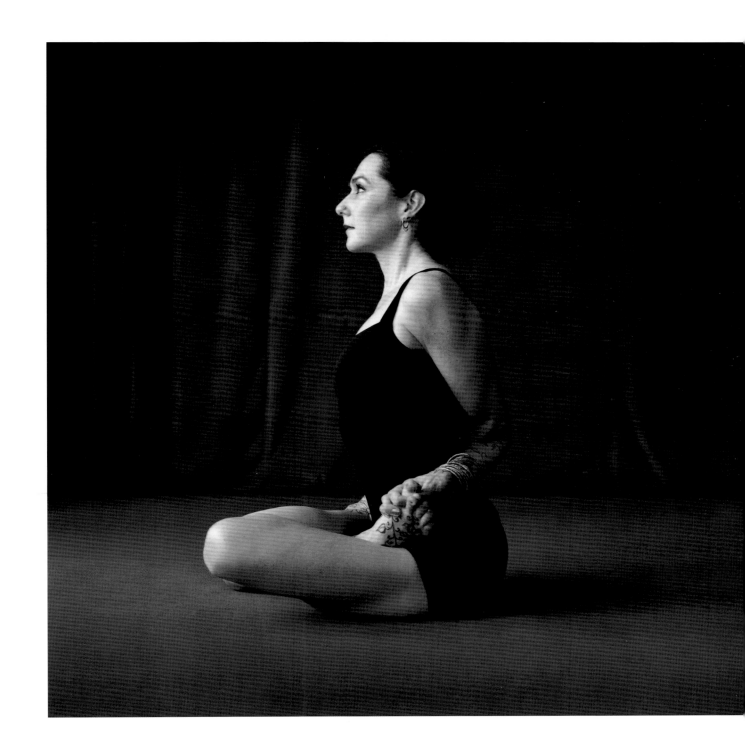

What is realized in the enlightened state is the oneness of being.

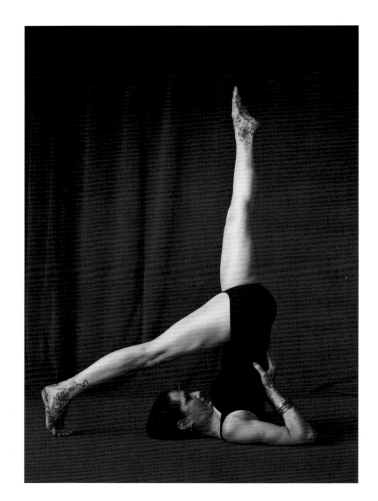

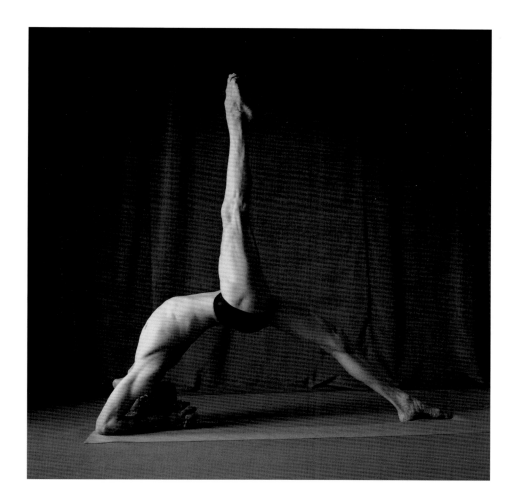

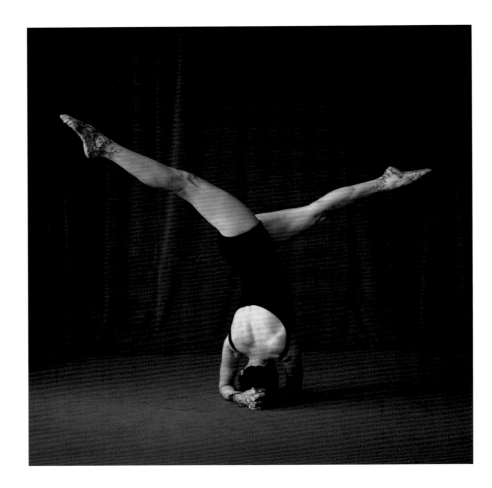

Freedom is a psychokinetic skill.

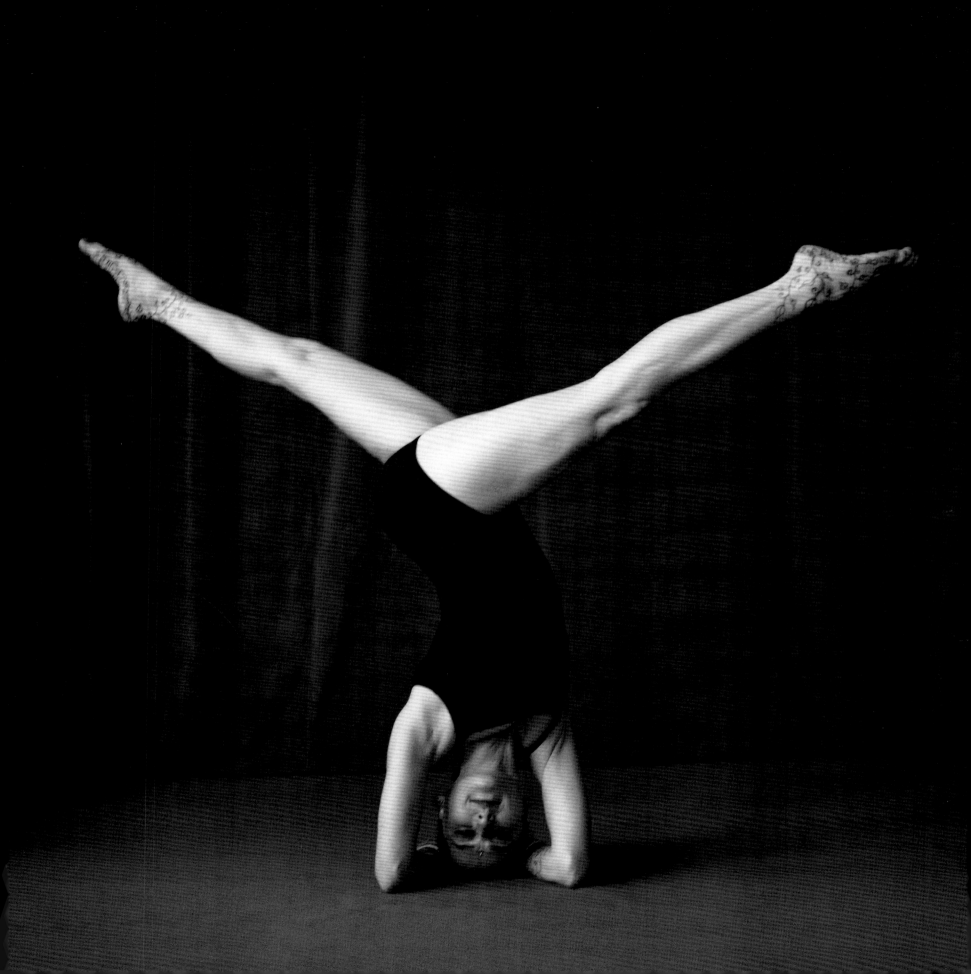

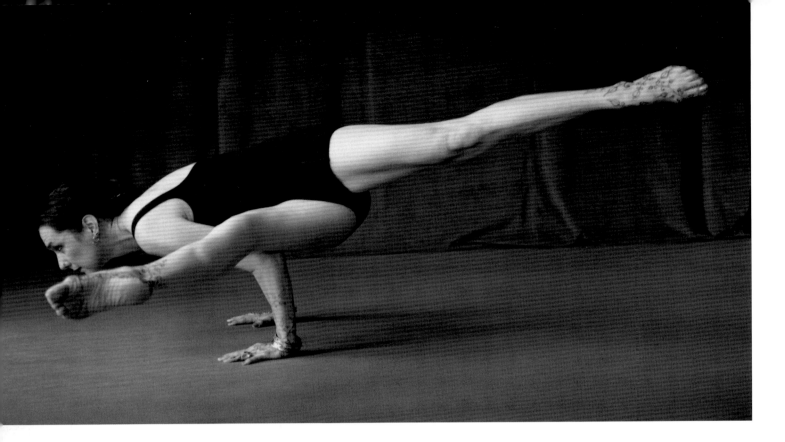

Eka Pāda Kouṇḍinyāsana

Garuḍāsana

EAGLE

52

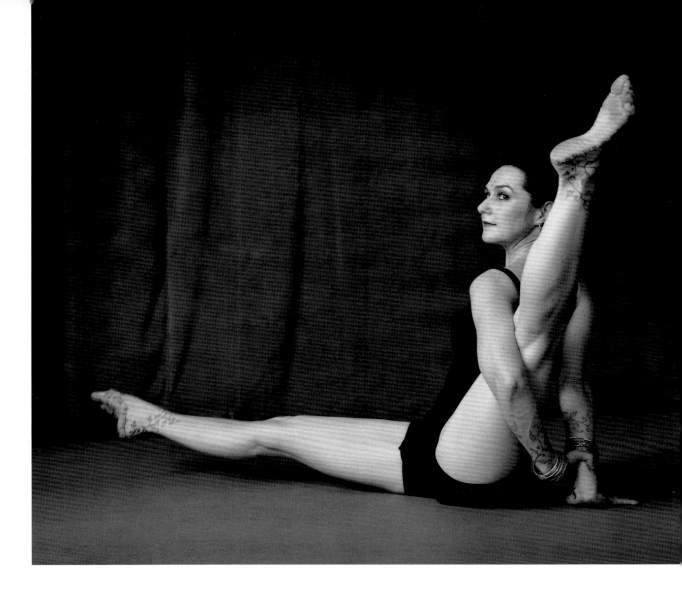

Koṇāsana

Each asana is like a sound or letter in an alphabet. Every letter in an alphabet produces a unique sound vibration. Each asana vibrates at a specific frequency. When asanas are performed in a sequence, beautiful phrases or sutras result, producing a mystical language.

We can do yoga practices that may reveal to us where we are resisting happiness. Once we are made aware of our tightness and uptightness, we can then begin to let go.

Gomukhāsana
COW FACE

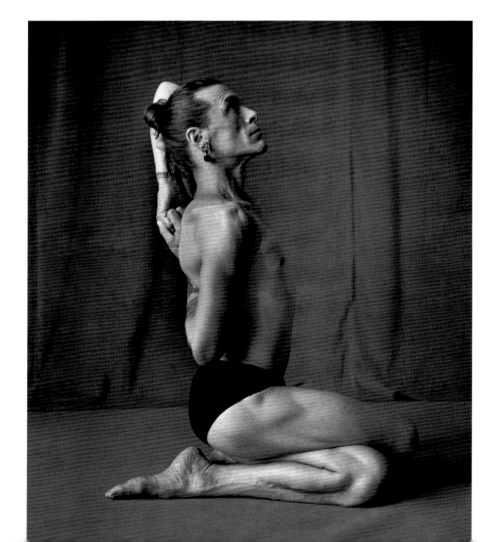

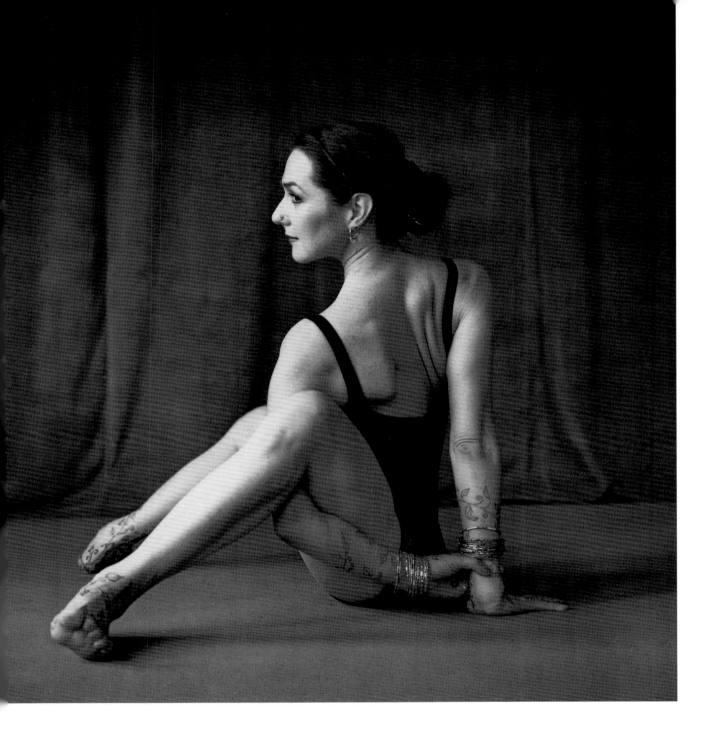

Parivṛtta Vikāsitakamalāsana

TURNING BLOSSOMING LOTUS

Yoga means joined or yoked. What the yogi is joined with is the eternal Self, which is happiness, boundless joy, and bliss.

Vāmadevāsana

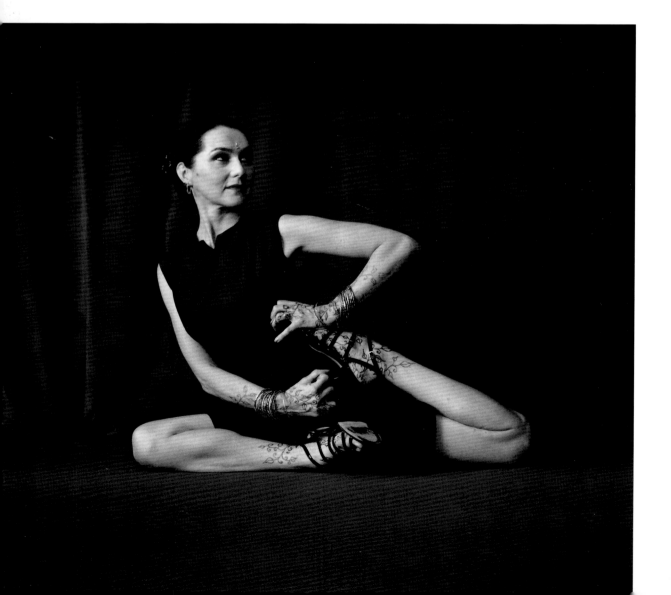

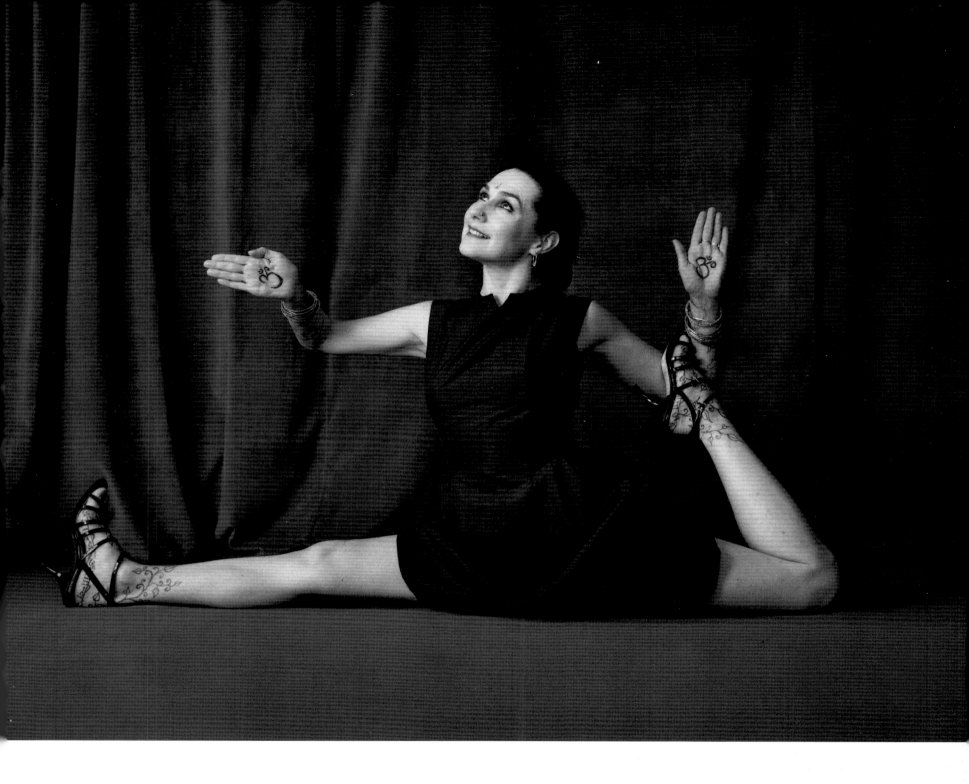

Eka Pāda Rājakapotāsana

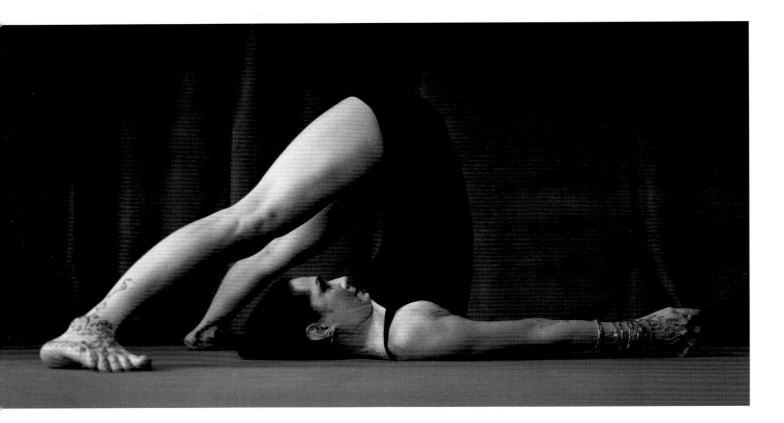

Sthira-sukham-āsanam

—Yoga Sūtra II.46

The connection to the earth should be steady and joyful

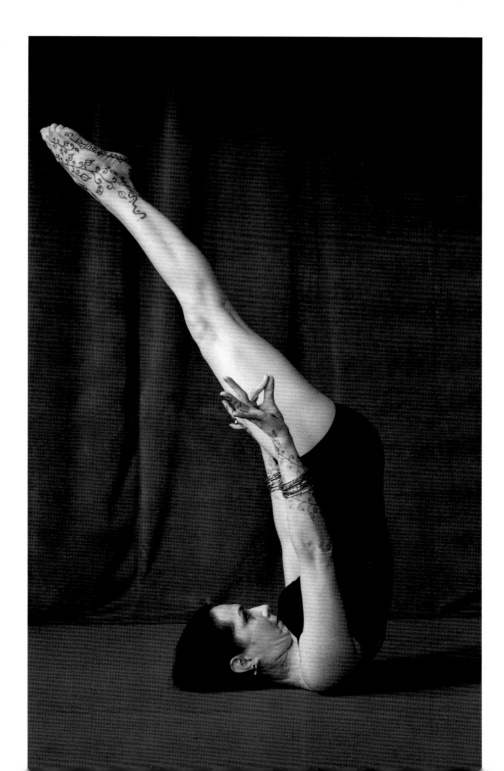

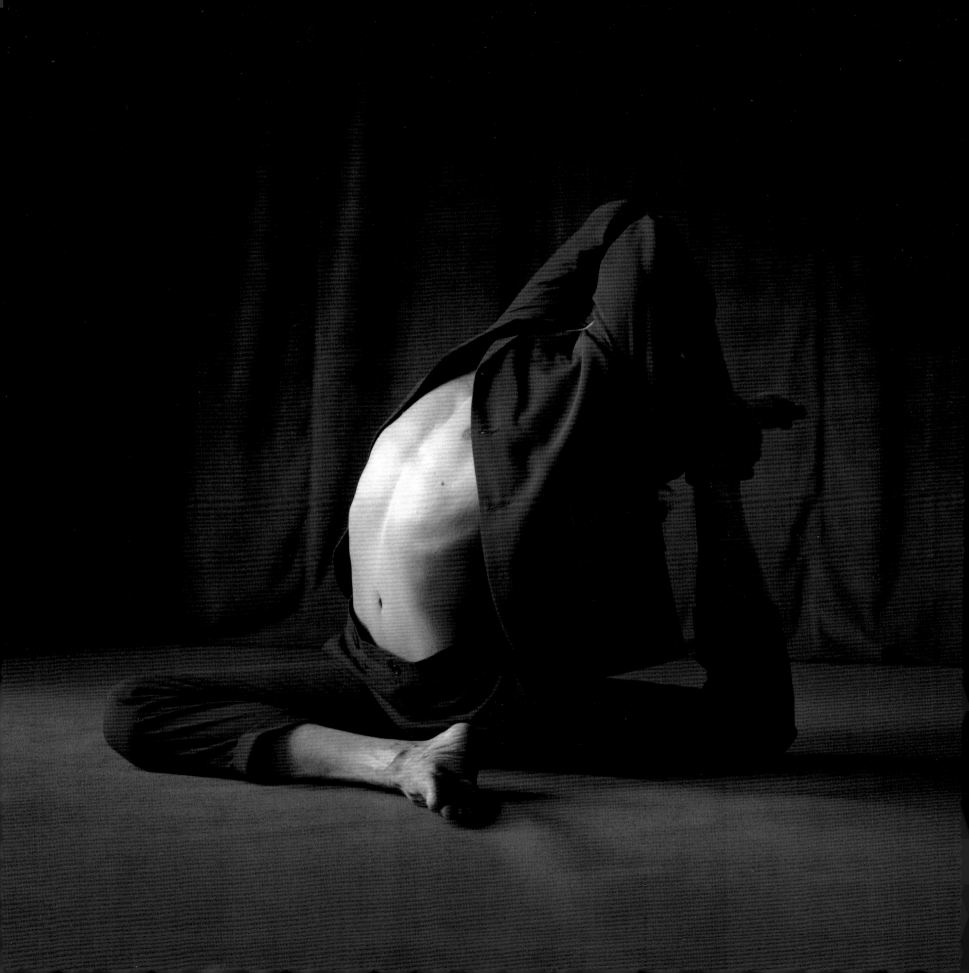

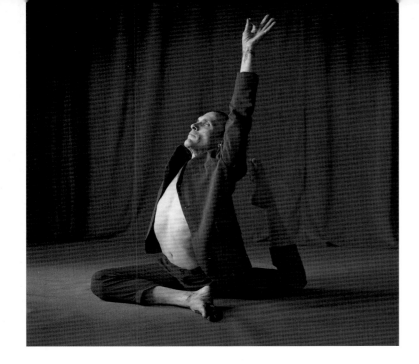

Rājakapotāsana

The art of life is life as art. *Yoga* means joining together what we do with who we are: Love itself.

Hanumānāsana

SEAT OF THE MONKEY GENERAL

Rājakapotāsana

KING PIGEON

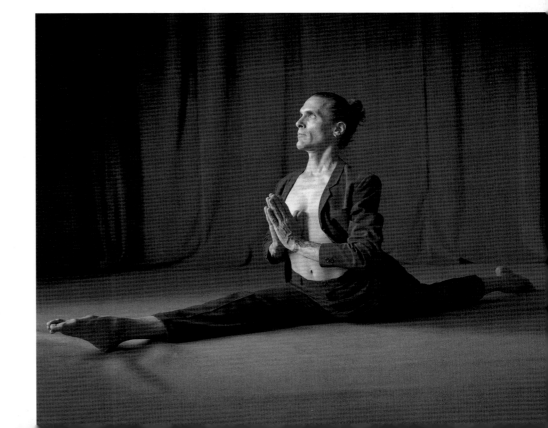

By witnessing or watching the breath, you eventually allow

the breath to breathe your body. You then come to know

you are not your body. You cannot watch and be what you

are watching at the same time.

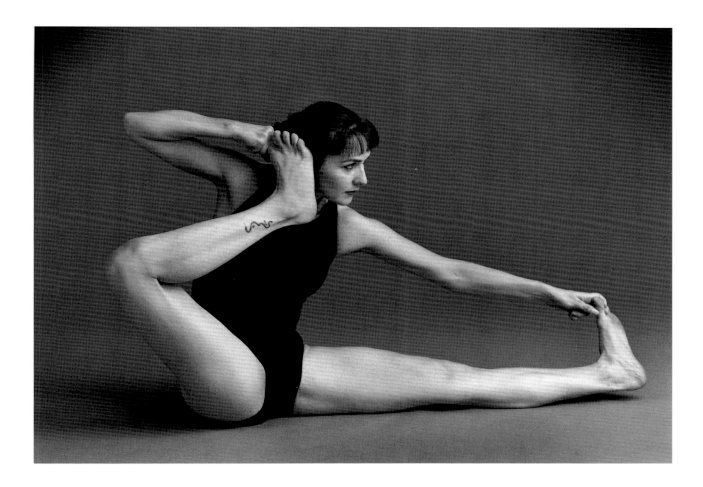

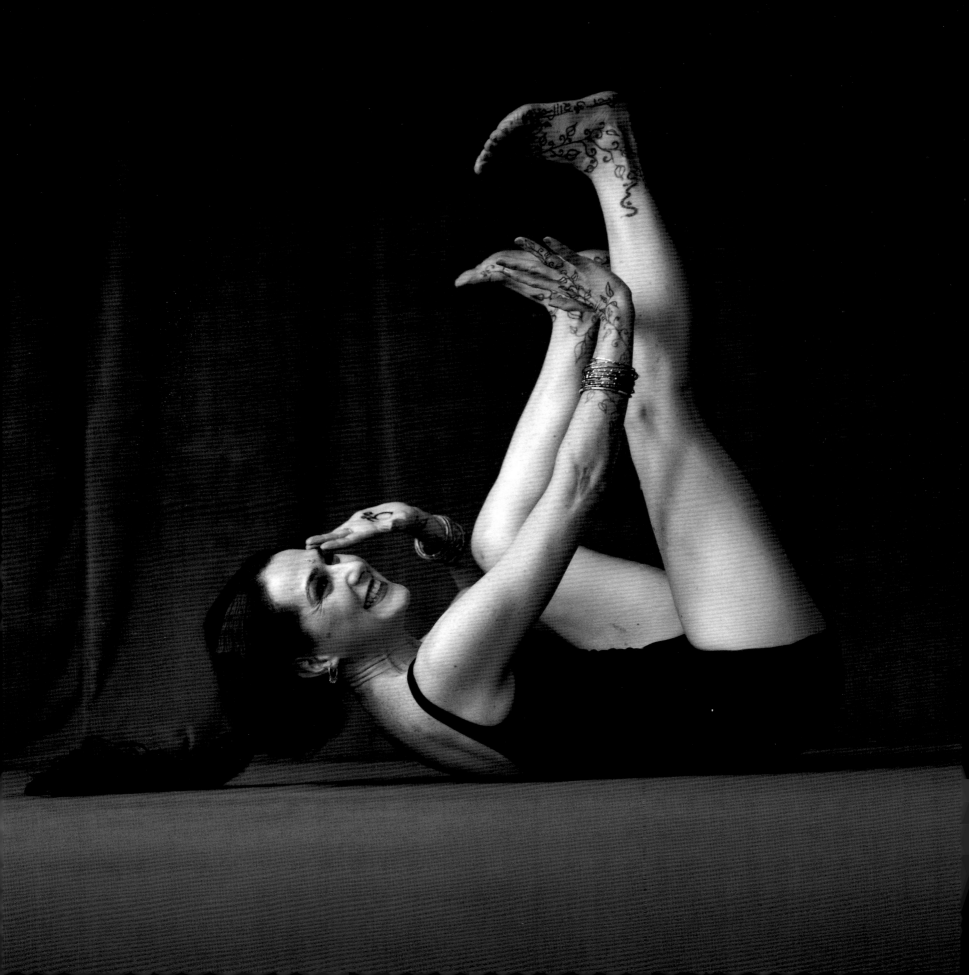

Hāsahāsana
LAUGH-ASANA

Happiness is the goal of yoga— the goal of life.

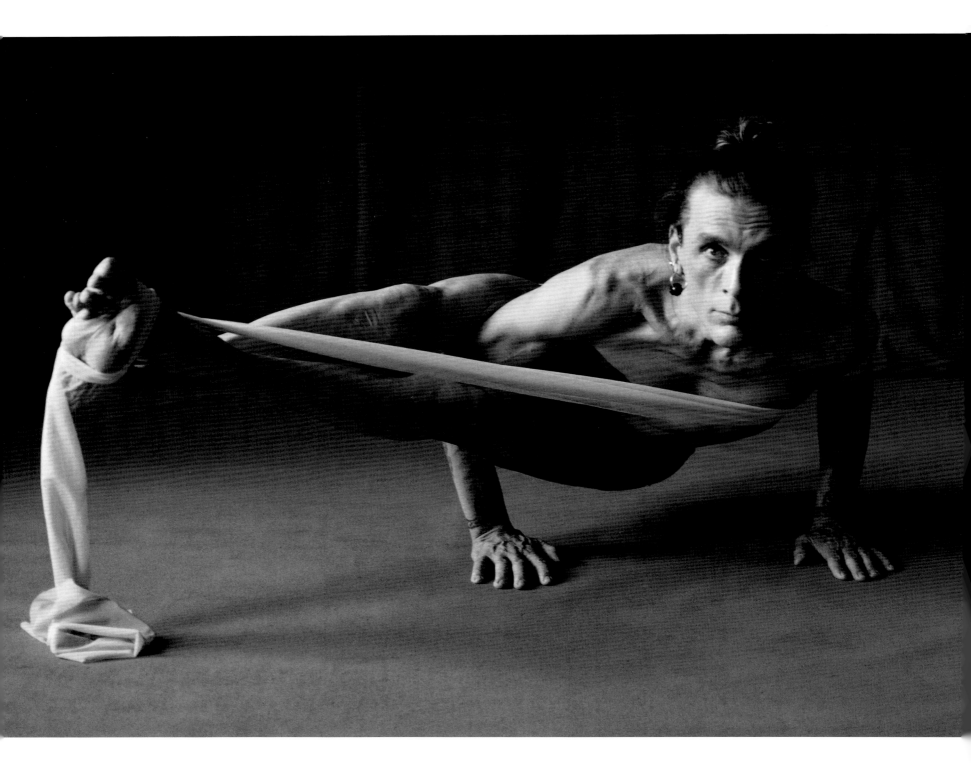

The inner essence is the common thread. Each gesture should express a commitment to the goal of Cosmic Consciousness. Just as each prayer should be authentic, each breath should be original and cherished as a unique expression of the absolute.

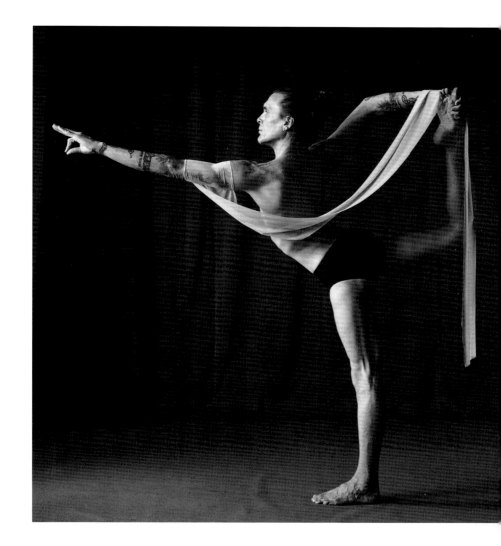

Naṭarājāsana

KING OF DANCE

Yoga practices help us develop awareness and detachment. When we can begin to watch our personality's fearful reactions to situations, we can develop compassion for our own lack of courage. Through compassion, we realize there is nothing to lose. There is nothing to grasp, nothing to get—we are everything.

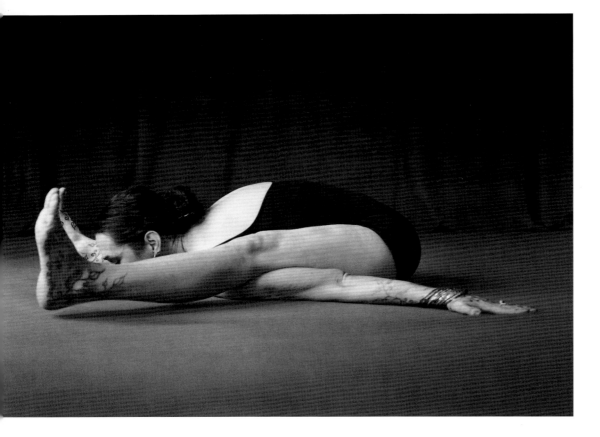

Kūrmāsana

THE TORTOISE WHO
SUPPORTS THE WORLD

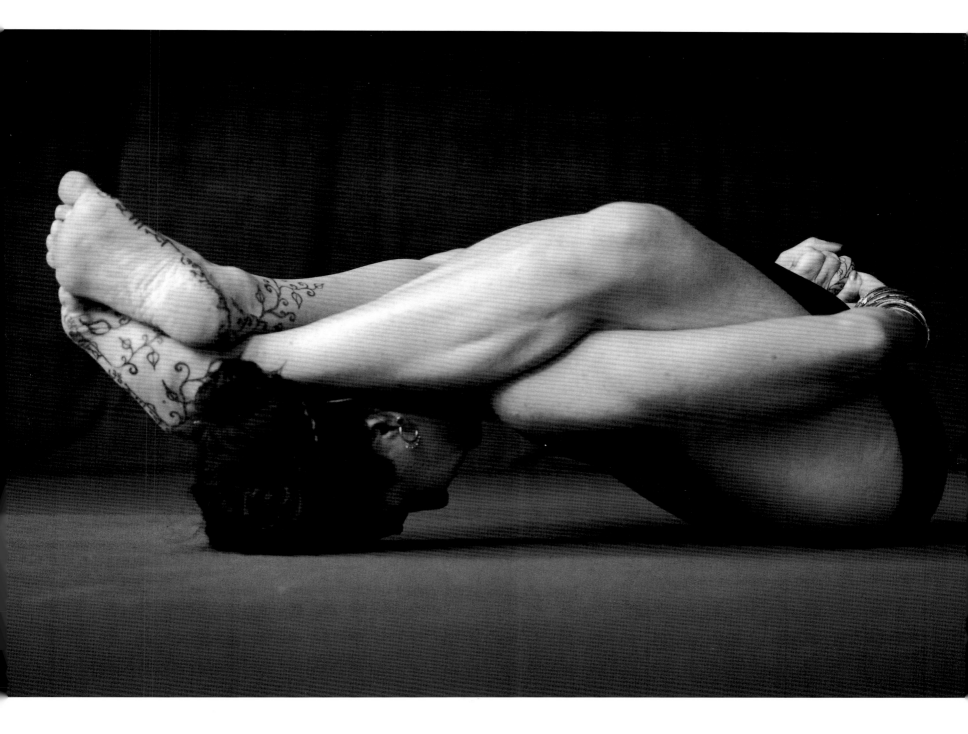

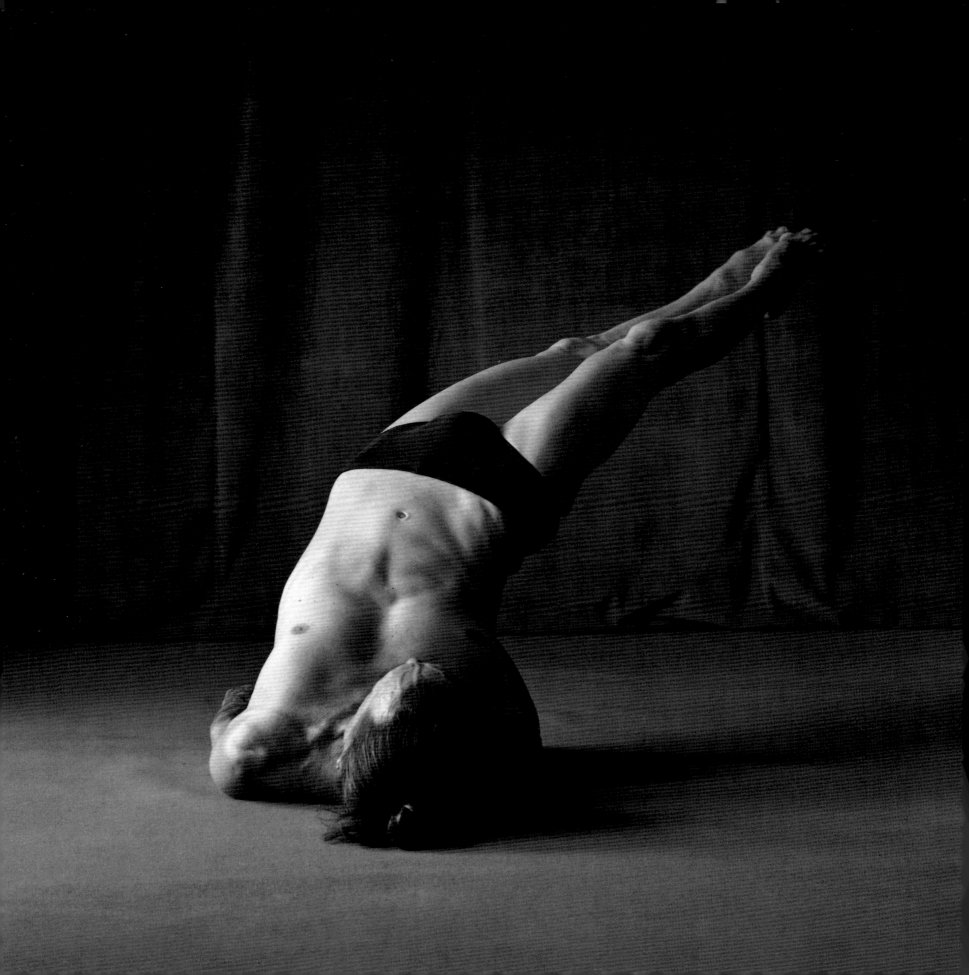

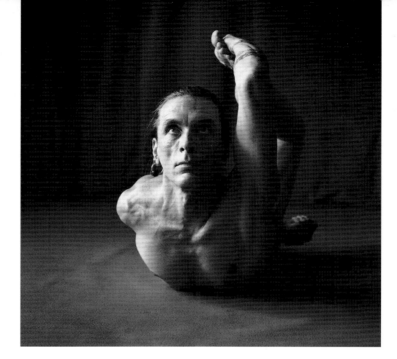

Realization occurs in a single moment. One must remain available to that graceful opportunity, regardless of daily obstacles. To share in the joy of revelation, we need to transcend the daily saga of trial and error, and see the perfection of each moment. We must act as if the entire universe depends on our actions, all the while laughing at such a thought.

Pārśva Sarvāngāsana

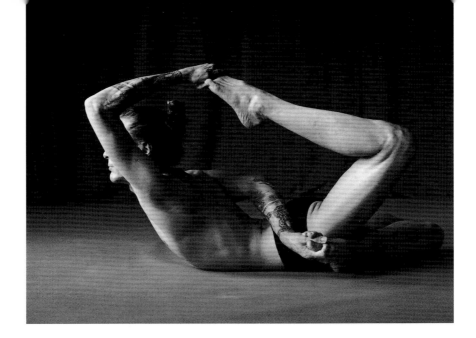

To the observer, an asana should look effortless.
Even when it is difficult, you imagine that it is not.

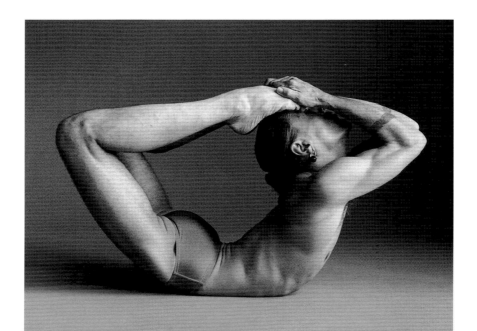

Everything arises through imagination, or lack of it. When we imagine and put our *prana,* our life force, behind that imagination, that thought is materialized in a form that has ease and lacks confusion. When we realize the potency of thoughts, we understand the importance of the purification of thoughts. Even though that inner struggle is continuous and difficult, it does not appear so on the outside. The yogi is divinely discontent. This is not a denial of body or feeling, but rather a method affecting states of mind with changes in the body and learning how the state of mind has created the state of the body.

Pādāṅguṣṭha Dhanurāsana

Muscle performance is limited. Muscles can contract or relax—they cannot do both at the same time. When the body is restricted and held in one shape the mind receives that shape like clay in the hand of a sculptor. Rather than adding new skills or aptitudes, yoga practice strips away the coverings from our own innate abilities. When the mind relaxes its stubborn desire to stay the same, ease and comfort are felt.

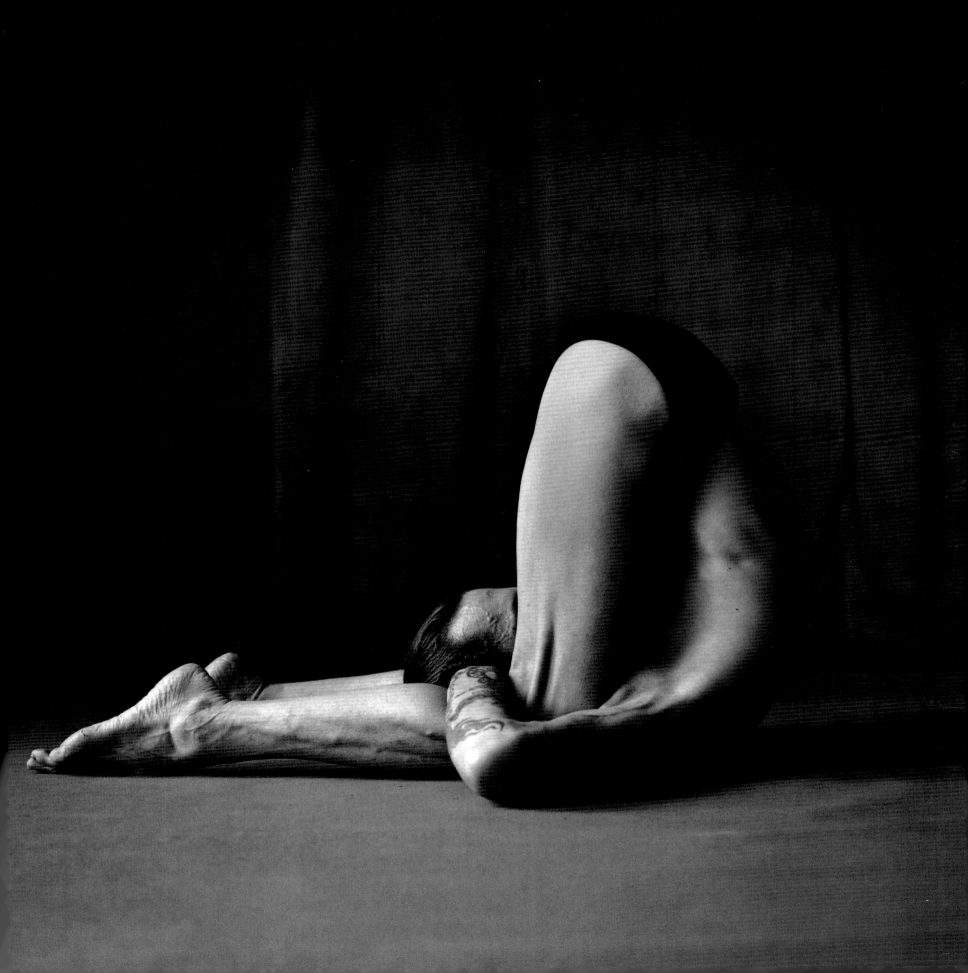

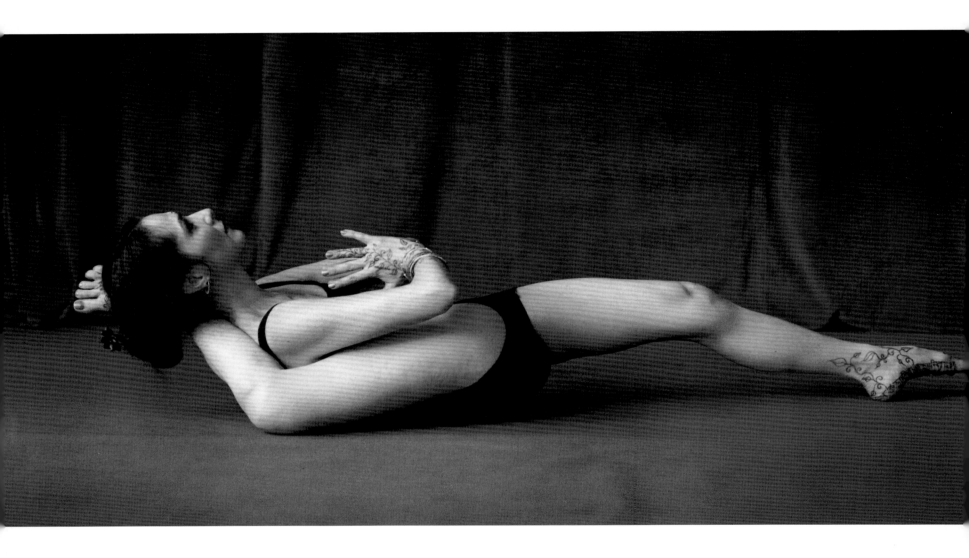

We can become stuck in habits of selfishness. The yoga asanas help us to overcome these habits by making us aware of them. When you practice asana you feel your resistances to joy. You feel your tendencies to anger, greed, jealousy, and sadness. Through this awareness you can begin to let go of these negative habits that distance us from joy.

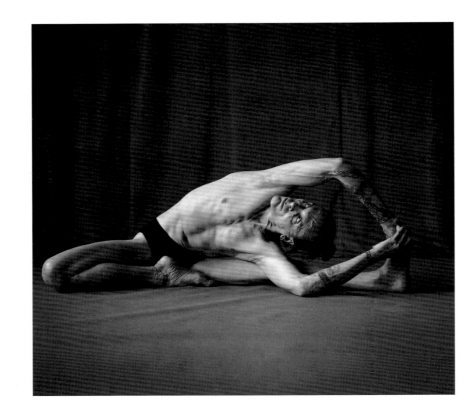

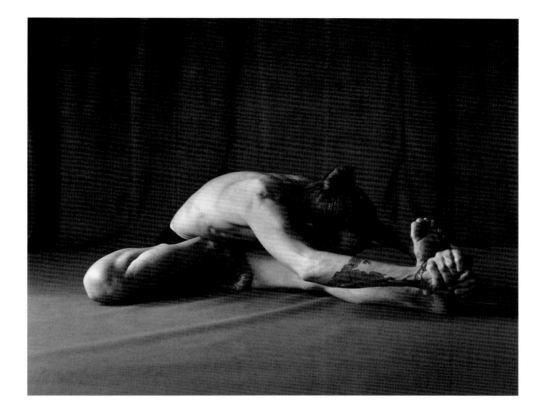

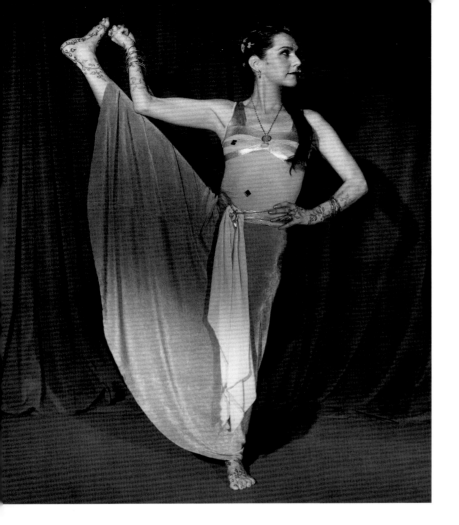

Friendliness toward the happy,
compassion for the unhappy,
delight in the virtuous, and
indifference toward the wicked
allow the mind to remain serene

—Yoga Sūtra I:33

Pārśva Hasta Pādānguṣṭhāsana

Dyaus Tantuvāyāsana

SKY-WEAVER

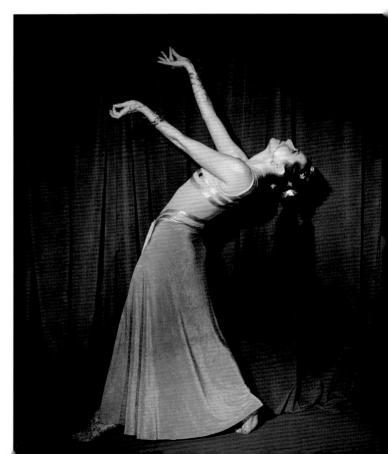

Eka Pāda Ūrdhva
Dhanurāsana

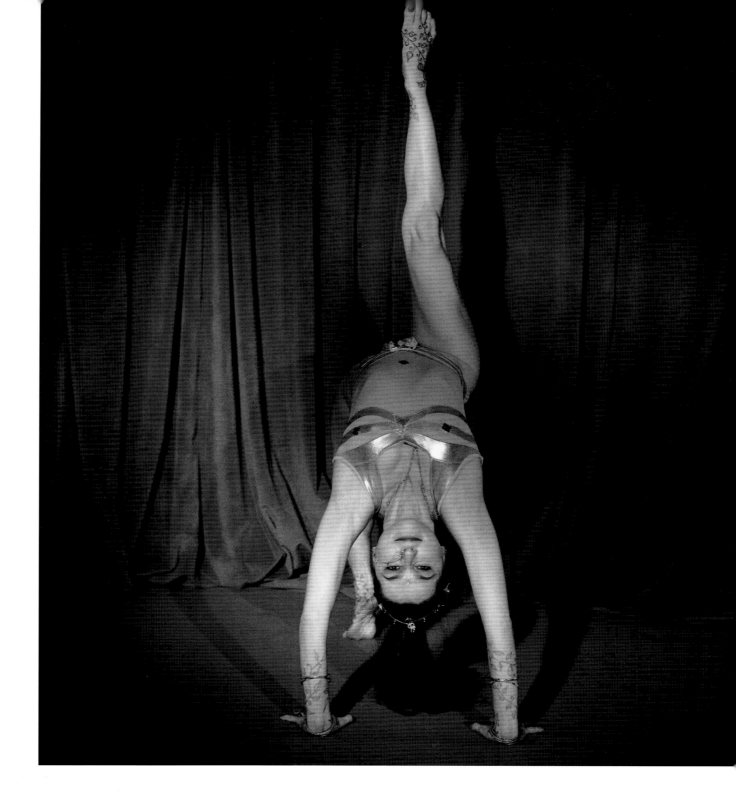

The relationship to the earth and all earthly beings

is the "seat" of the yogi. When that relationship has

integrity, unity, duration, and love, it is masterful.

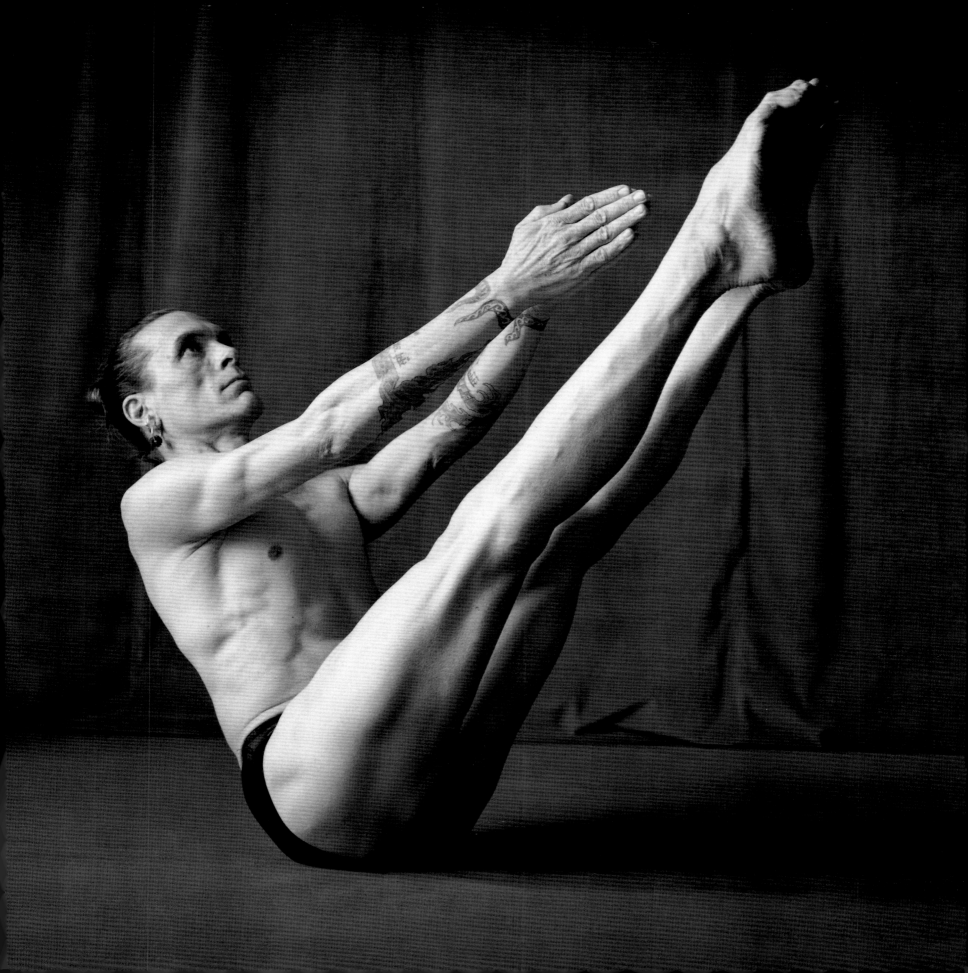

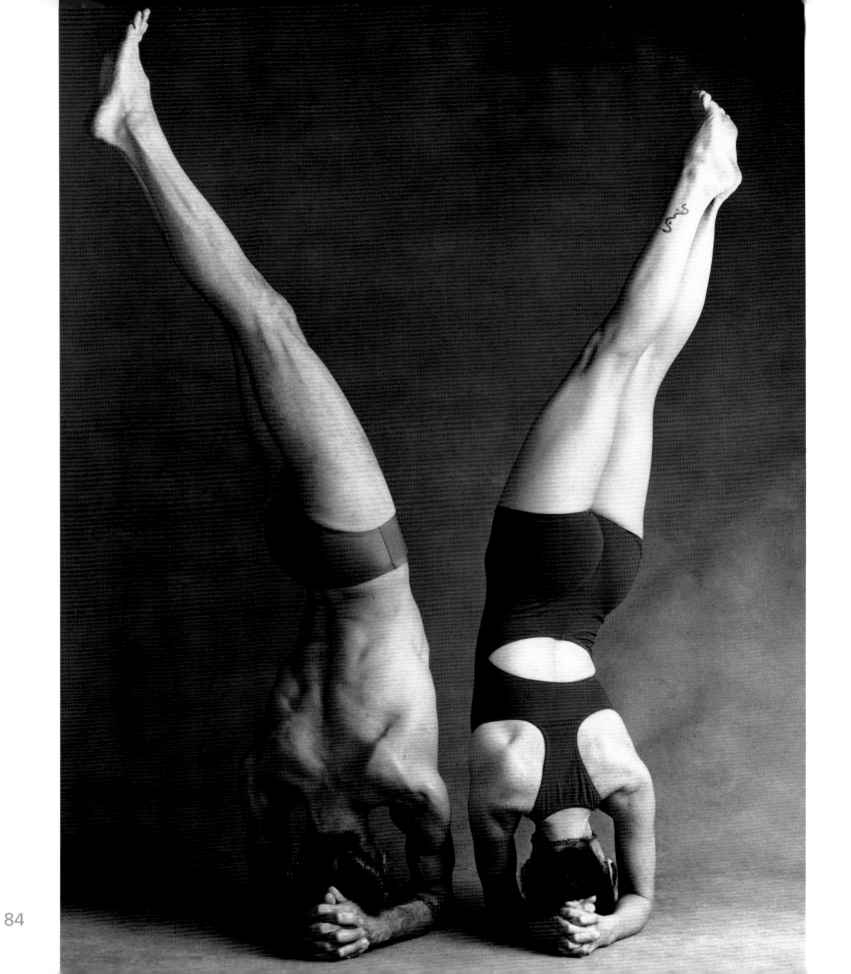

Hathasya pratāṃa anga tvādāsanaṃ purvam ucyate.

Kuryā tada āsanam sthairyaṃ ārogayaṃ ca aṅgā lāghavaṃ.

— Hatha Yoga Pradīpikā I.17

Asana is an important limb of Hatha Yoga. As a result of asana a steadiness in body and mind energies is achieved; the body is free of disease and the mind is freed from attachments.

We spend the first part of our lives trying to acquire an identity, and the remainder of our lives desperately defending that identity. By letting go of that identity, we dare to venture into the unknown: Our potential.

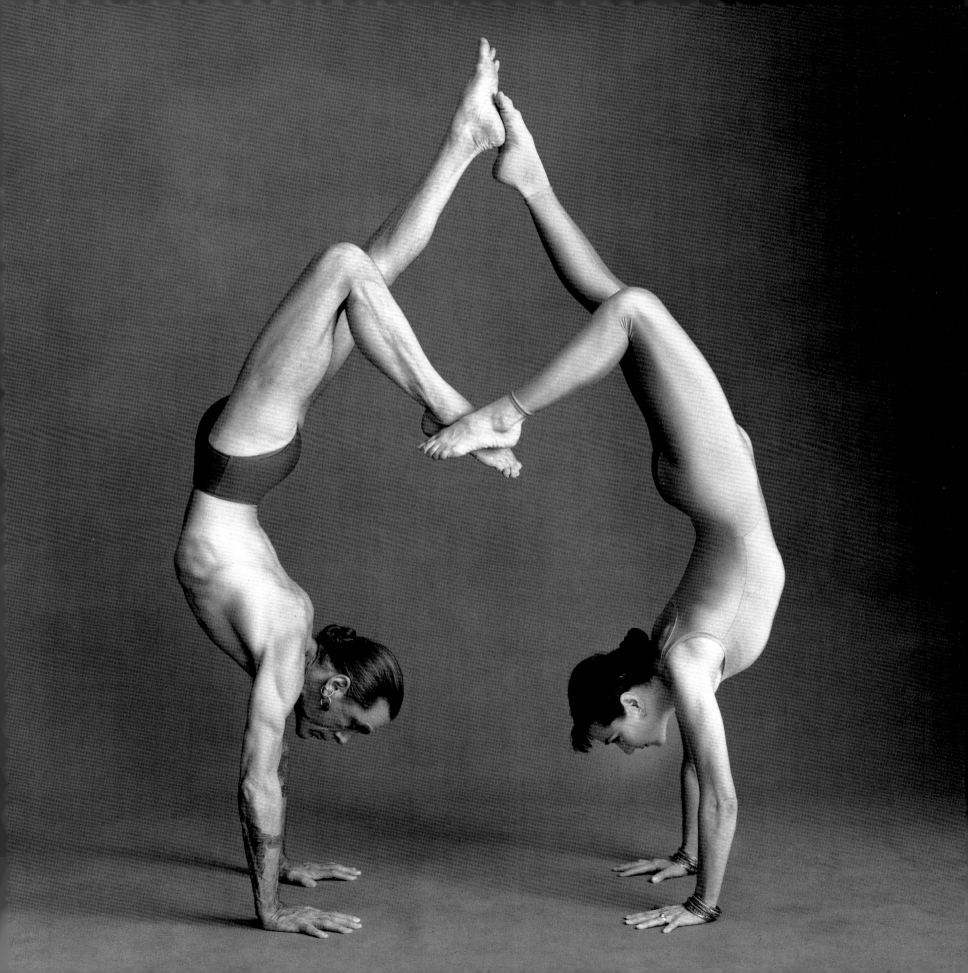

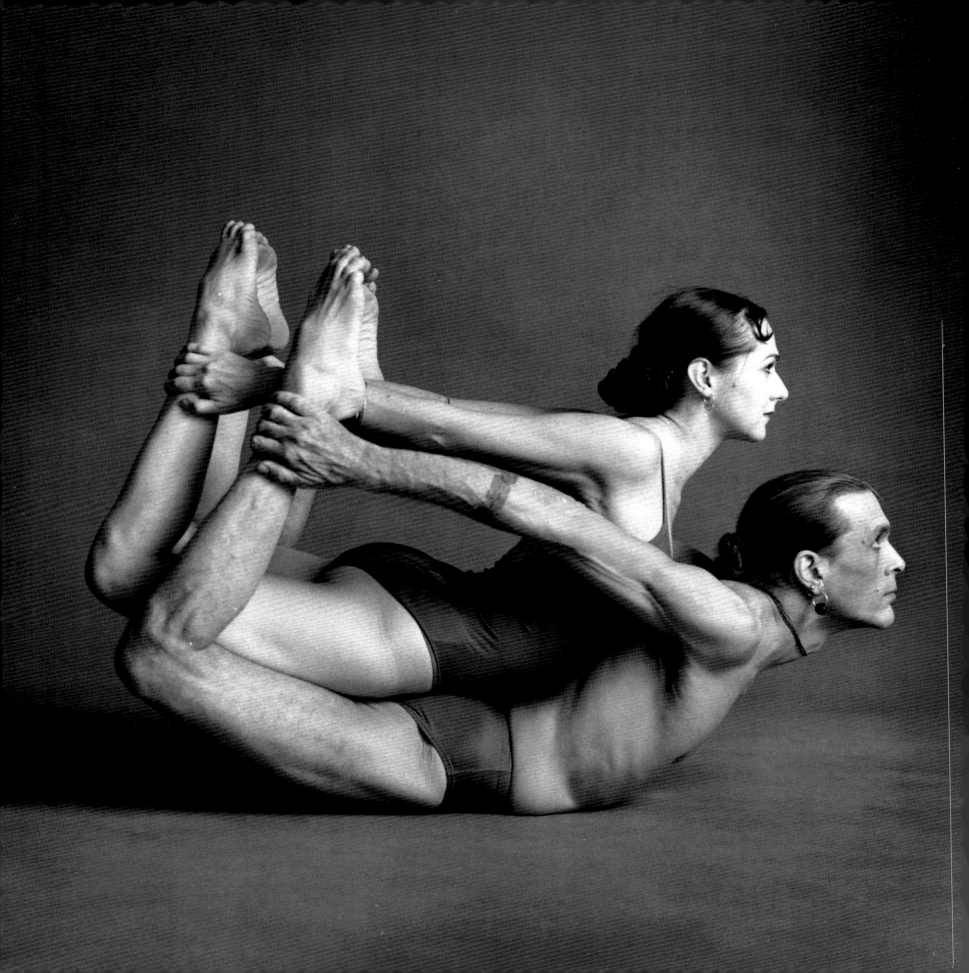

Dvaṃdva Dhanurāsana

Dvaṃdva Padmāsana

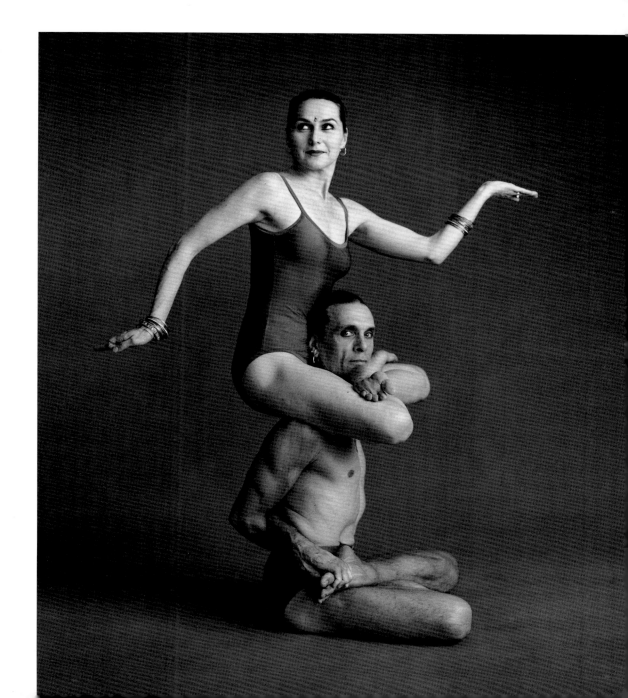

The image of the yogi on a bed of nails represents doing a form of *tapas,* or intense work. These physical positions are like the nails, or difficulties, in a practice. The yogi feels every nail in the bed and each eccentric twist of the body, but chooses not to focus attention on that discomfort. Instead of focusing on sensations in the body, the yogi directs attention beyond the pain toward true identity, creating ease and happiness in the midst of difficult situations.

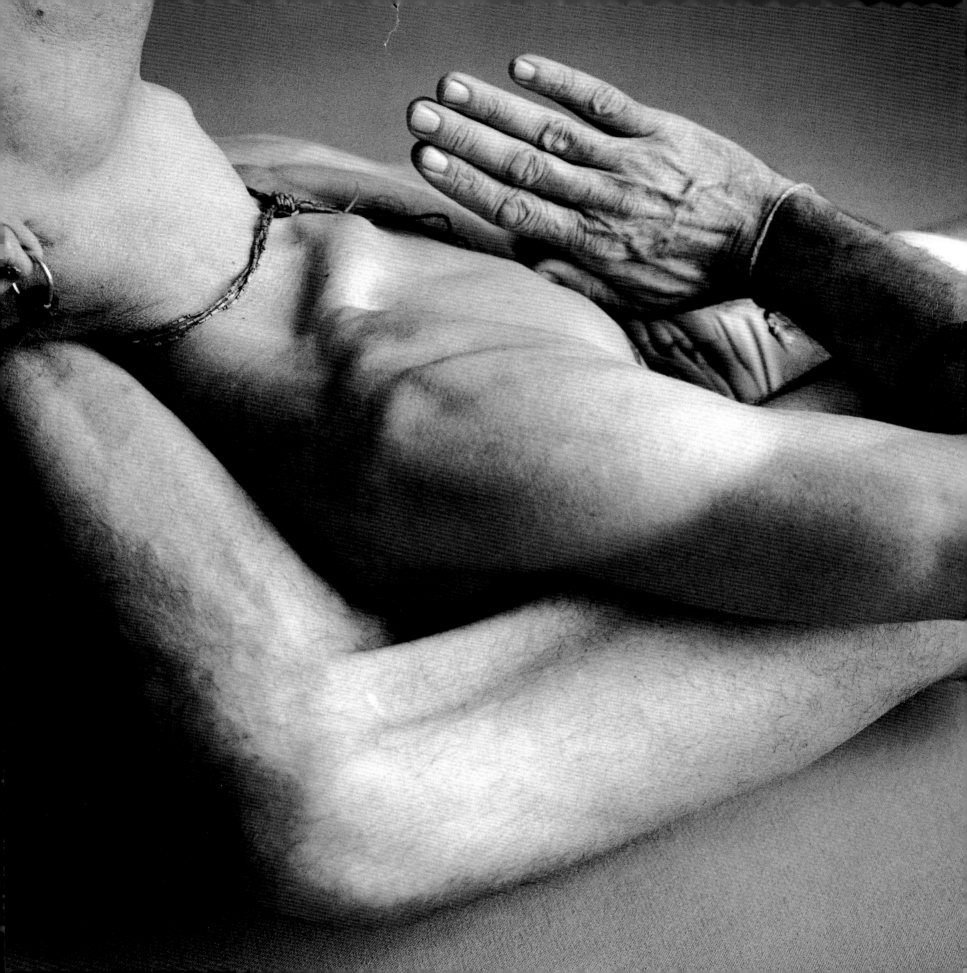

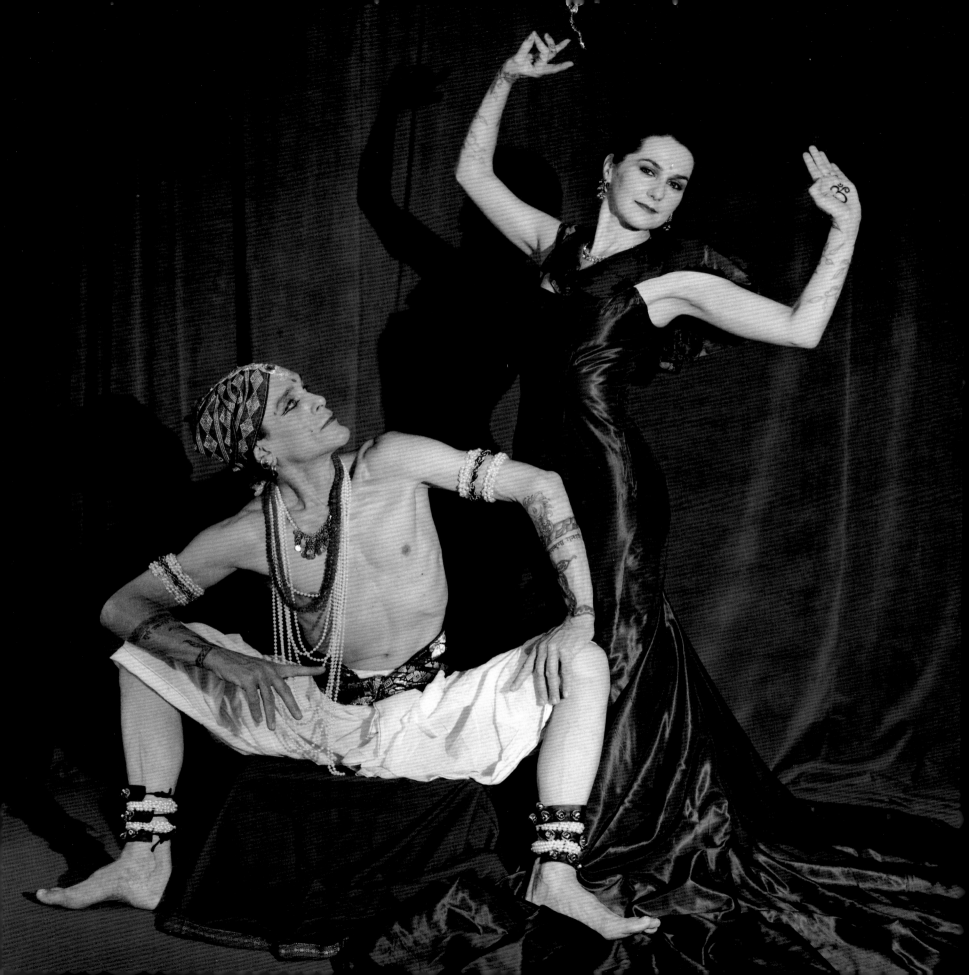

Joy will help to develop equanimity of mind.

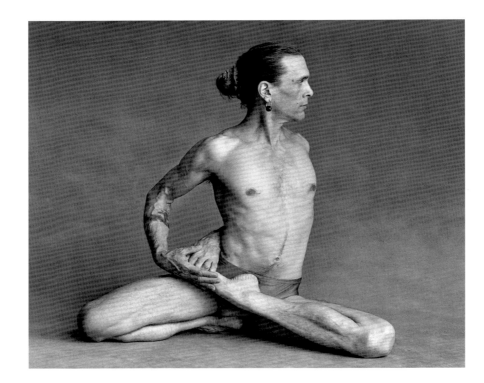

The nature of creation is change and movement. An asana practice can build resilience to the changeable nature of life. By strengthening the ability to breathe smoothly and think smoothly in any situation we acquire the ability to stay calm and do our best in any situation. Behind that smooth breath is clarity and vision, a glimpse into the infinite. Through constant practice the breath should be rendered unaffected by the difficulty of any physical situation in the same way that the mind should be calm in spite of outer circumstances.

Compassion is the key to happiness, the cause of enlightenment.

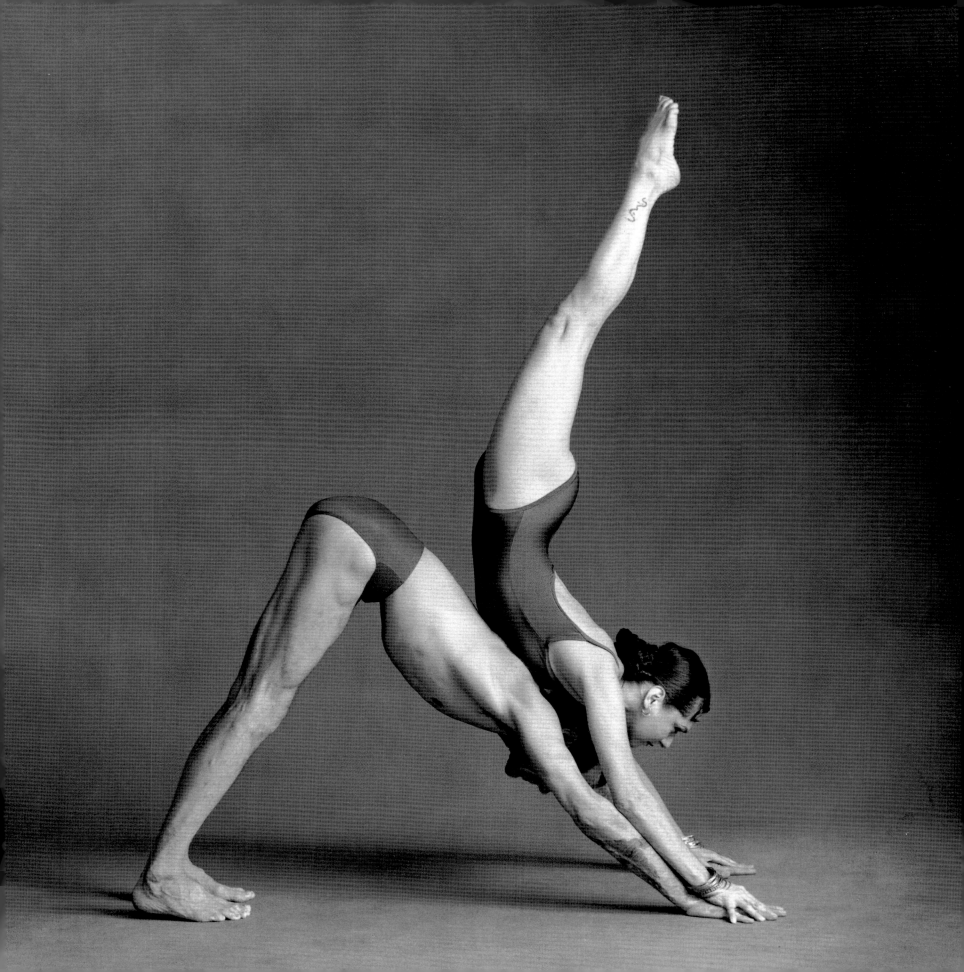

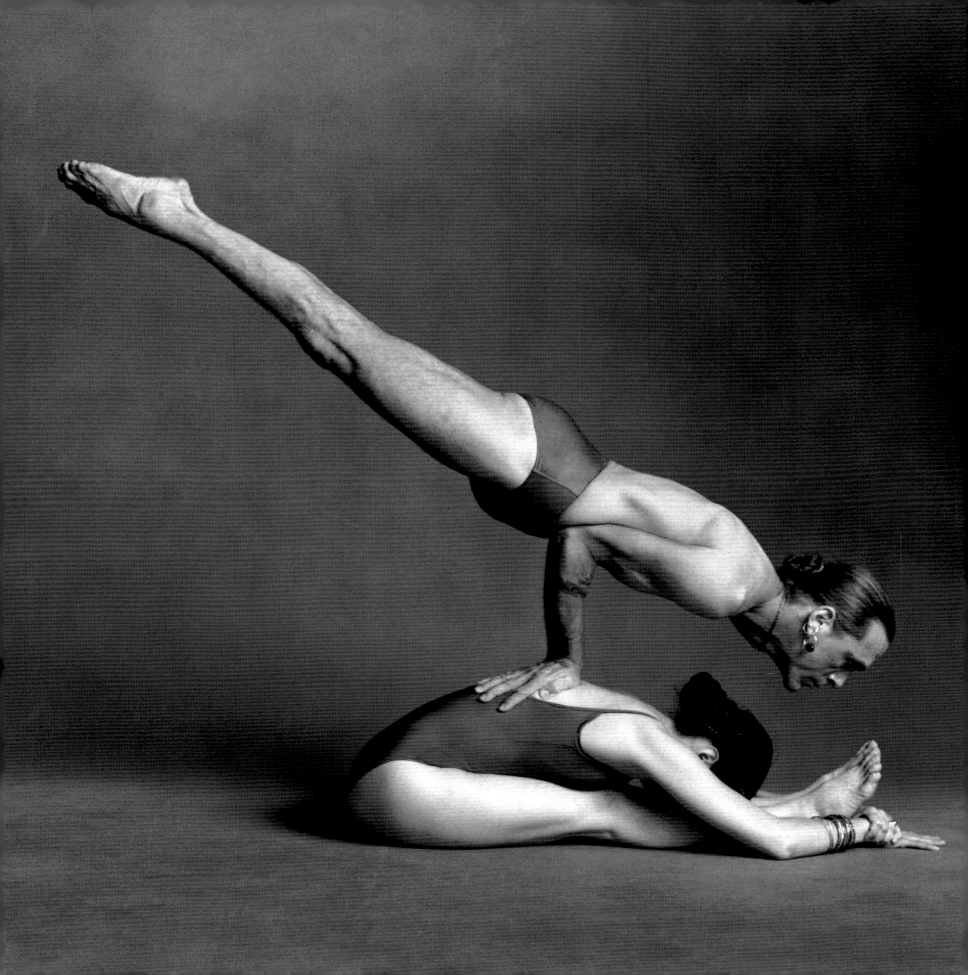

Tapaḥ svādhyāya Iśvara praṇidhānāni kriyā yogaḥ

—Yoga Sūtra II.1

Intense discipline, self study, and devotion to God are the

purifying actions which result in the attainment of yoga

Chaturanga Daṇḍāsana
THE FOUR-LEGGED STICK

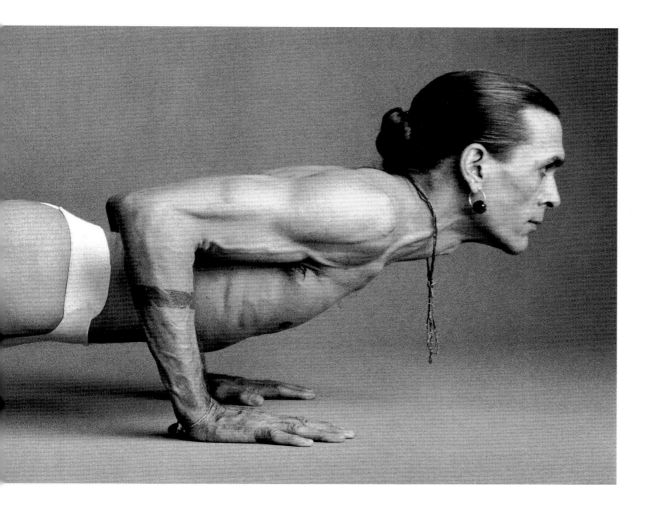

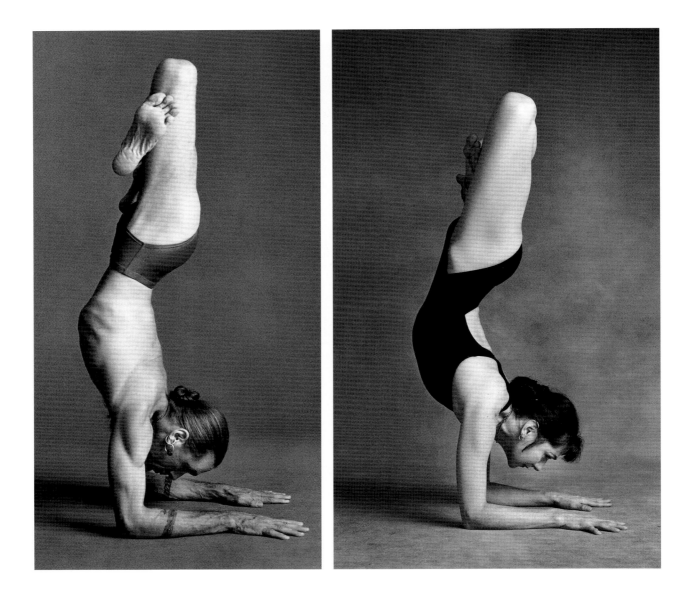

Padma Pincha Mayūrāsana
THE LOTUS IN THE PEACOCK FEATHER

Flexibility of mind

as well as body

allows for

adaptability and

ease of being in

an ever-changing

world.

Most of us are motivated by two forces: *raga* and *dveṣa*. We have excessive attachment to what we like (*raga*) and recoil from what we don't like (*dveṣa*). Through the practices of yoga equanimity of mind results, and we overcome our preferences.

We are like the continuous tumbling of clouds
Or the endless possibilities of a seashell.

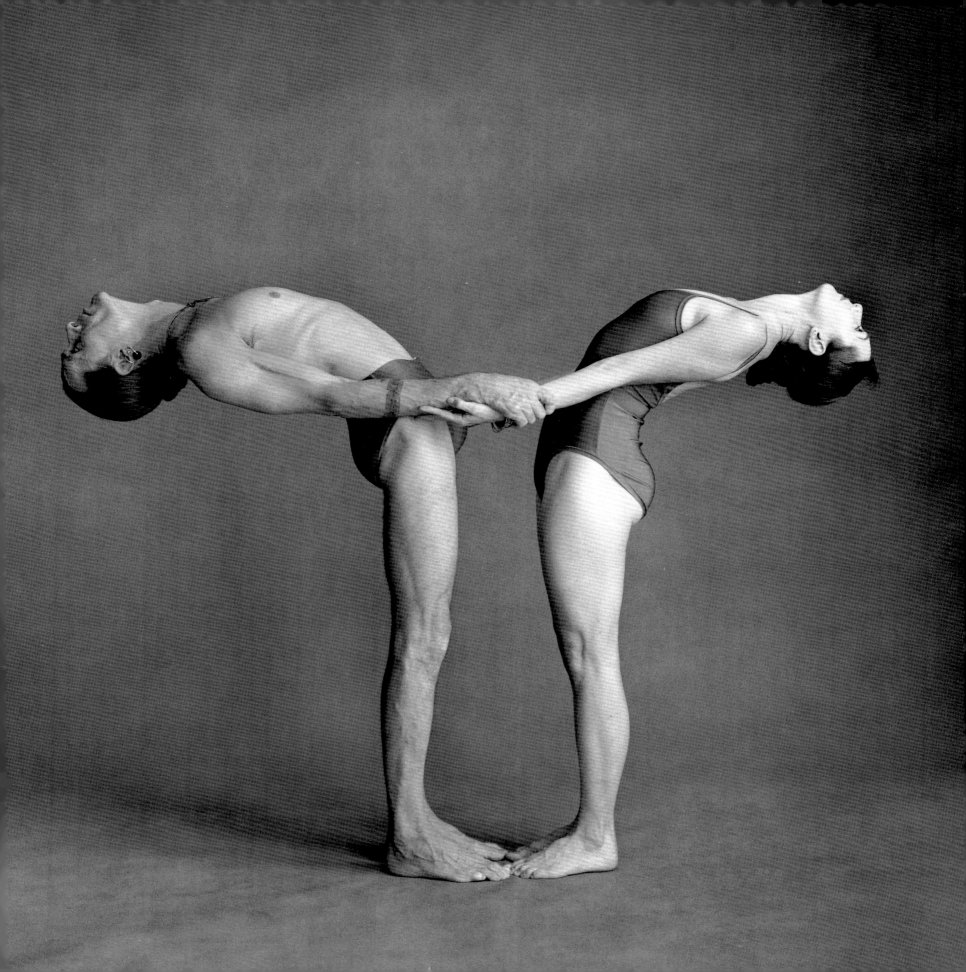

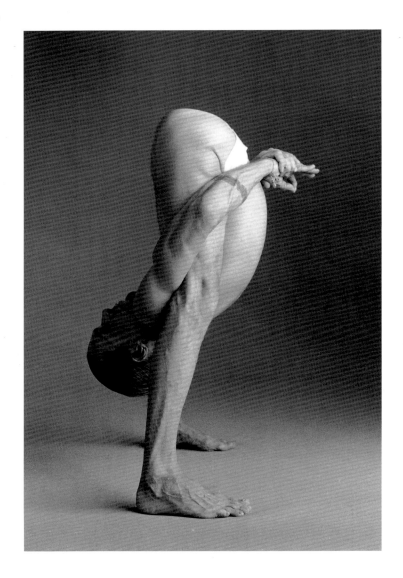

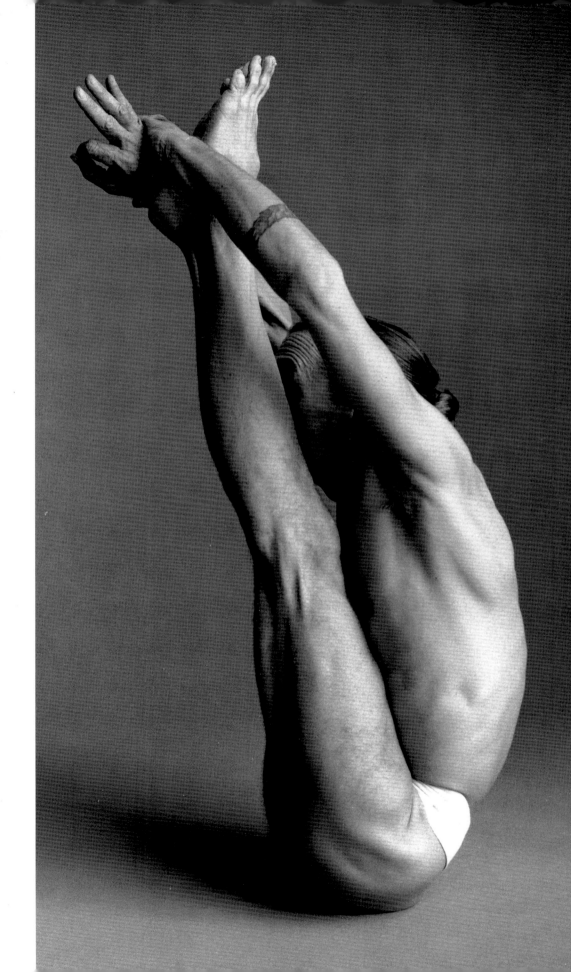

Ūrdhva Mukha Pachimottānāsana

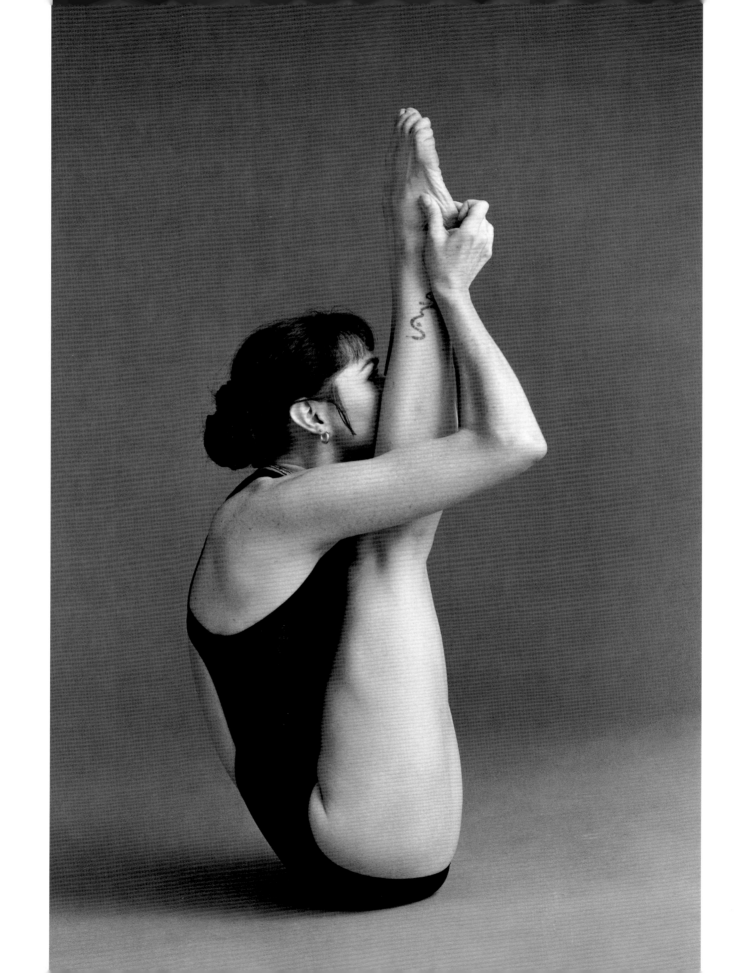

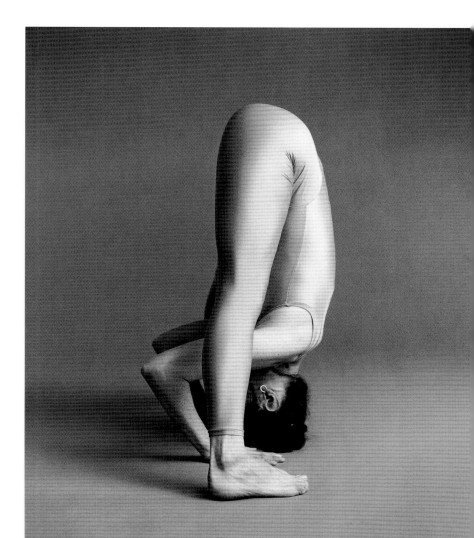

Ūrdhva Mukha Paschimottānāsana

When we achieve the perfect balance of upward moving forces and downward moving forces we embody an integrated whole that has the potential to transcend the limitations of a dual world.

Prasārita Pādottānāsana

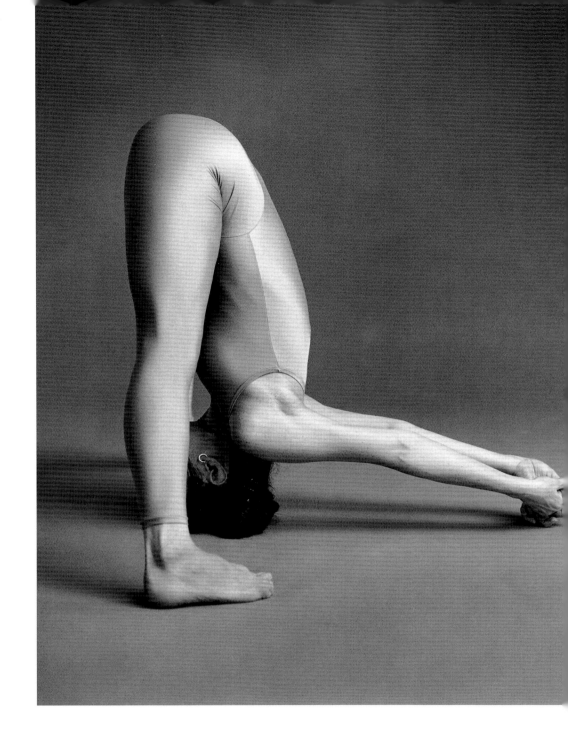

Dwi Pāda Śīrṣāsana

When we change our physical perception of the world from right side-up to upside down, we allow the mind to subside into the heart.

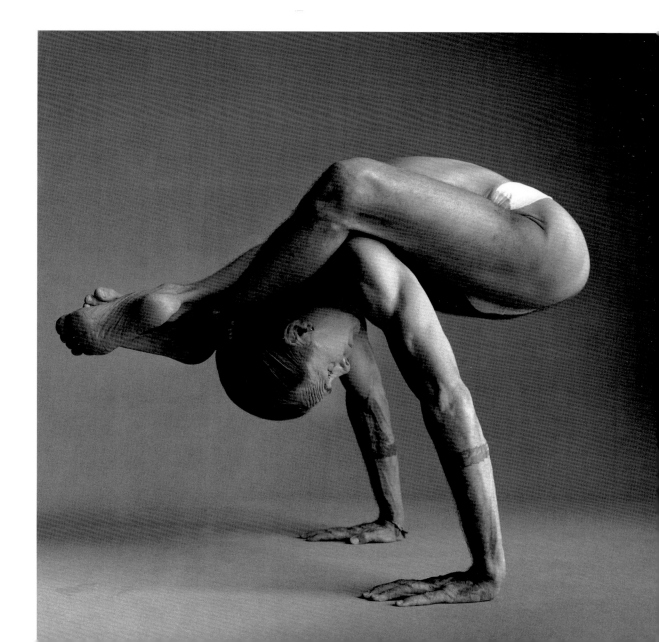

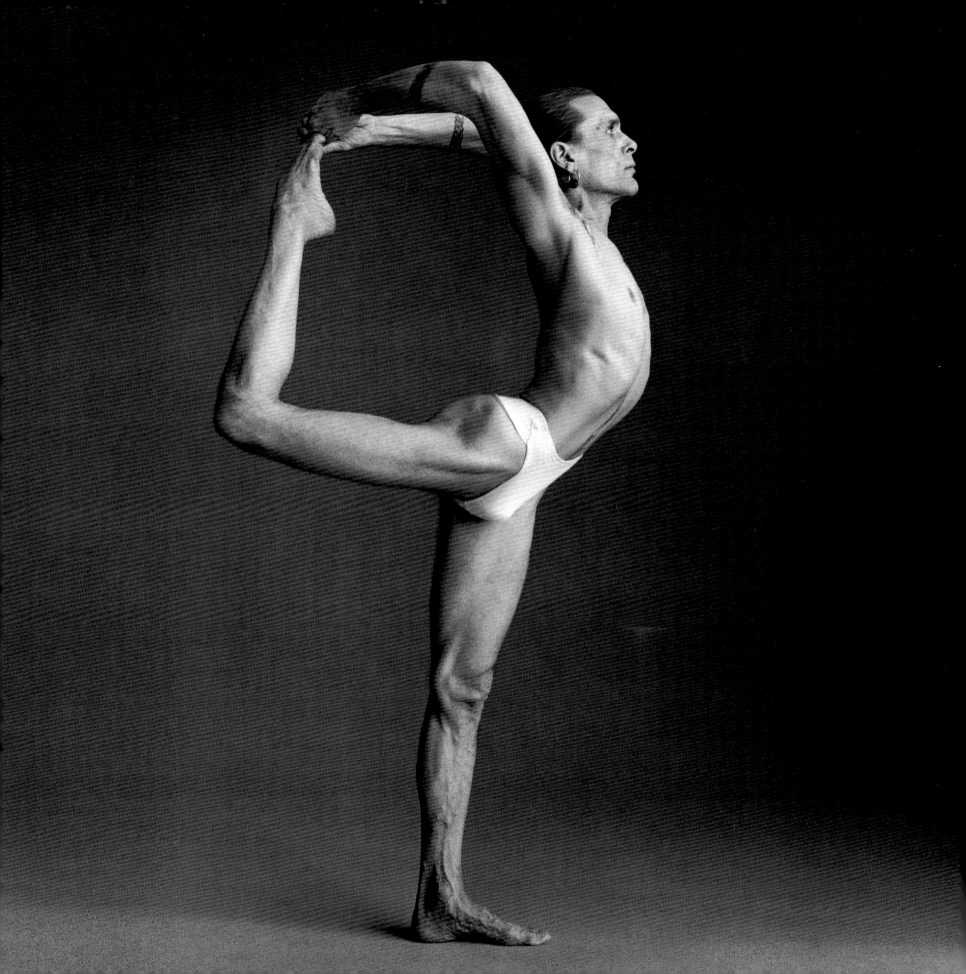

The human body's total range of possible movements is normally restricted to a small number of acceptable movements. The acceptability of any movement is gauged by many standards including fashion, culture, gender, or age. These outer restrictions to movement profoundly affect the inner state of mind. For example, the military march is designed to enforce an unquestioning and servile state of mind, whereas eccentric gestures may express creativity.

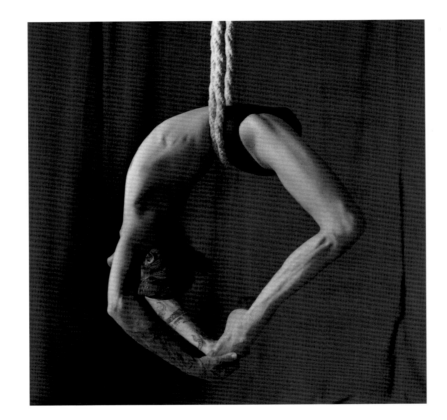

Kuruṇṭi Chakra Bandhāsana
THE PUPPET WHEEL

Pādanguṣṭha Dhanurāsana

HOLDING THE BOW

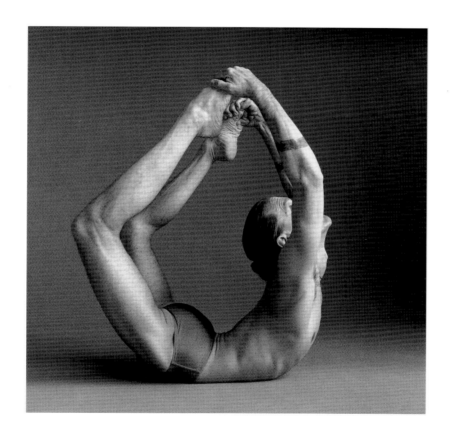

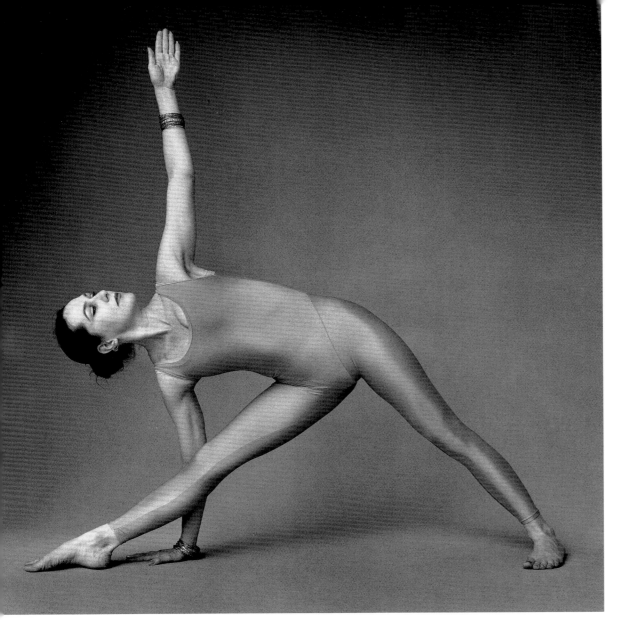

Utthita Trikoṇāsana

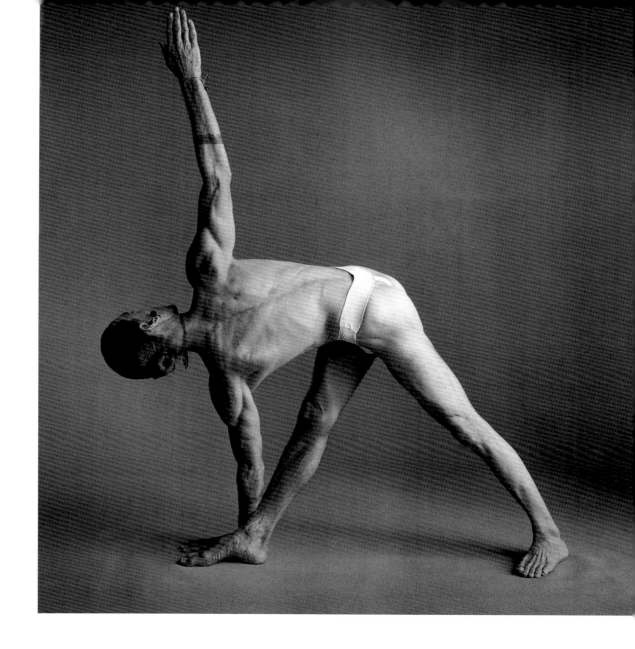

Parivṛtta Trikoṇāsana

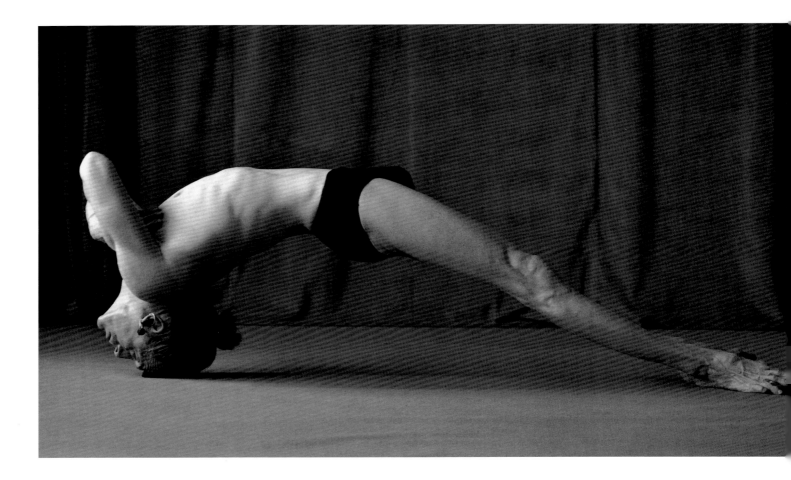

Setu Bandhāsana

BUILDING A BRIDGE

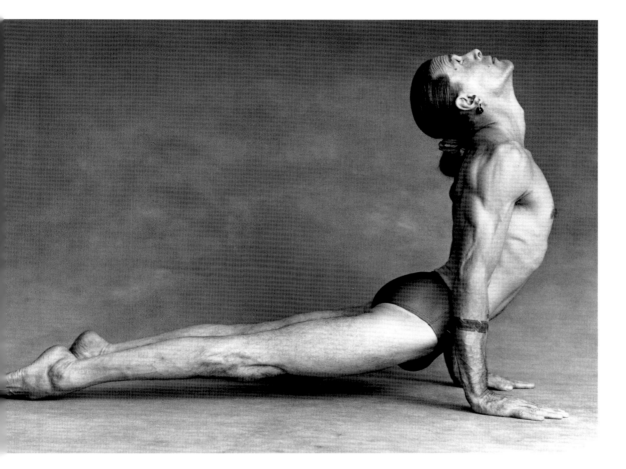

The sweep of an arm
Welcomes your eye.
The arch of a torso
Dignifies the ribs.
A cavernous theater
Where heart plays with diaphragm
And spirit makes a home.

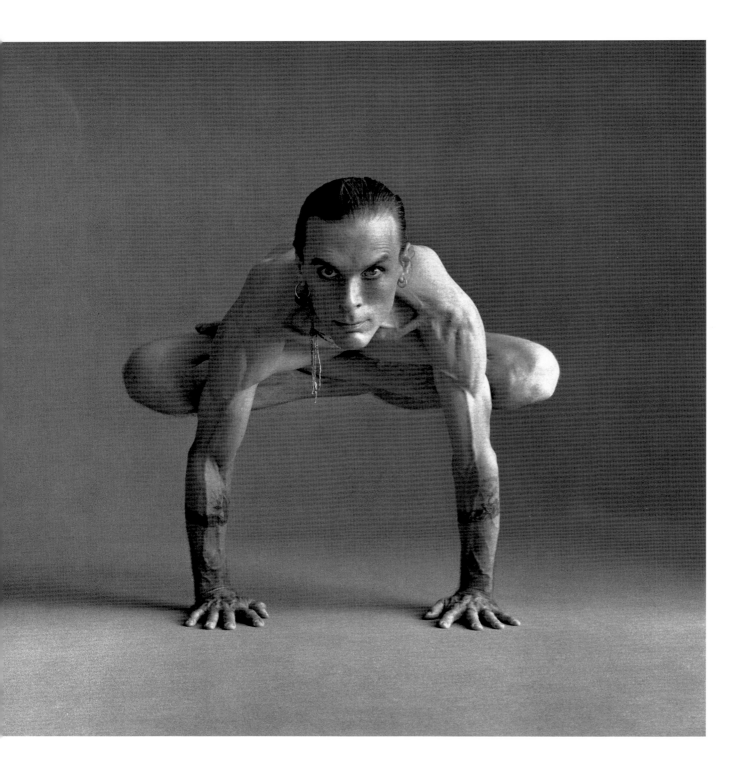

Ūrdhva Kukkutāsana

THE ROOSTER

We sometimes take the ability to communicate with bodily gestures for granted. Each gesture carries with it a potency and clarity. All animals use gestures to communicate to each other the thoughts in their minds and the feelings in their hearts.

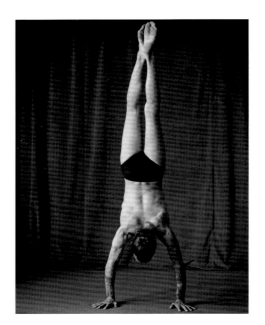 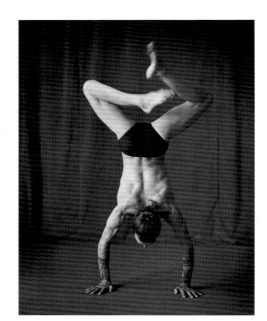 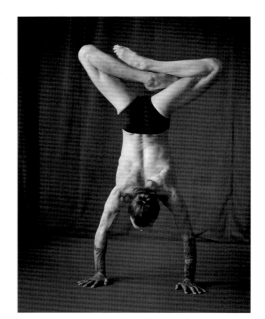

Moving Sequence to:
Padma Adho Mukha Vṛkṣāsana

LOTUS IN THE TREE

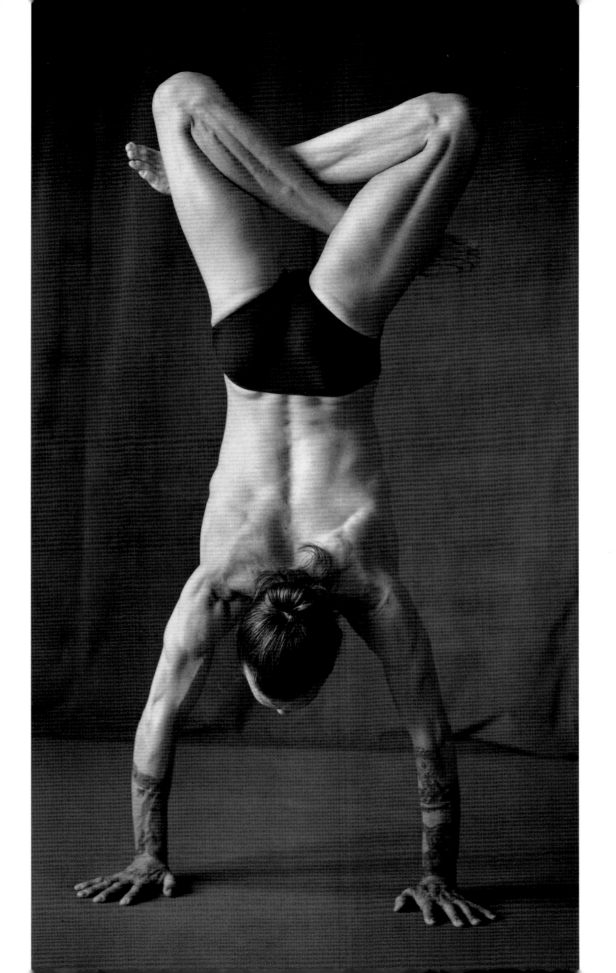

All creatures deserve happiness and freedom. Many obstacles stand in their way. Asanas are small obstacles we erect between our happiness and ourselves in order to prepare for the large hurdles in life. If we put all of our attention on the momentary hurdles in life and forget the ultimate goal, the obstacles become insurmountable. When our attention is fixed on the goal—which is super-consciousness or happiness—each barrier is cleared easily. When the vision is clear, the means will appear.

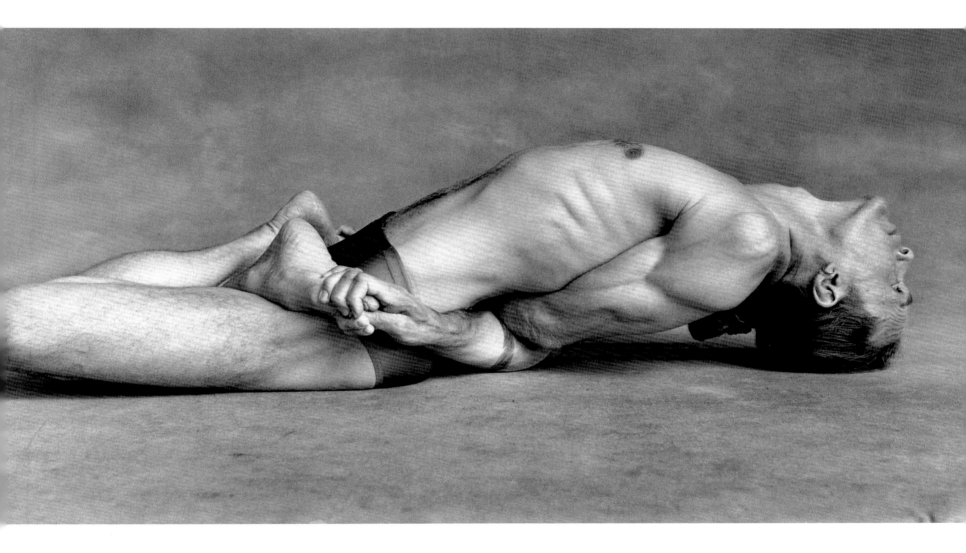

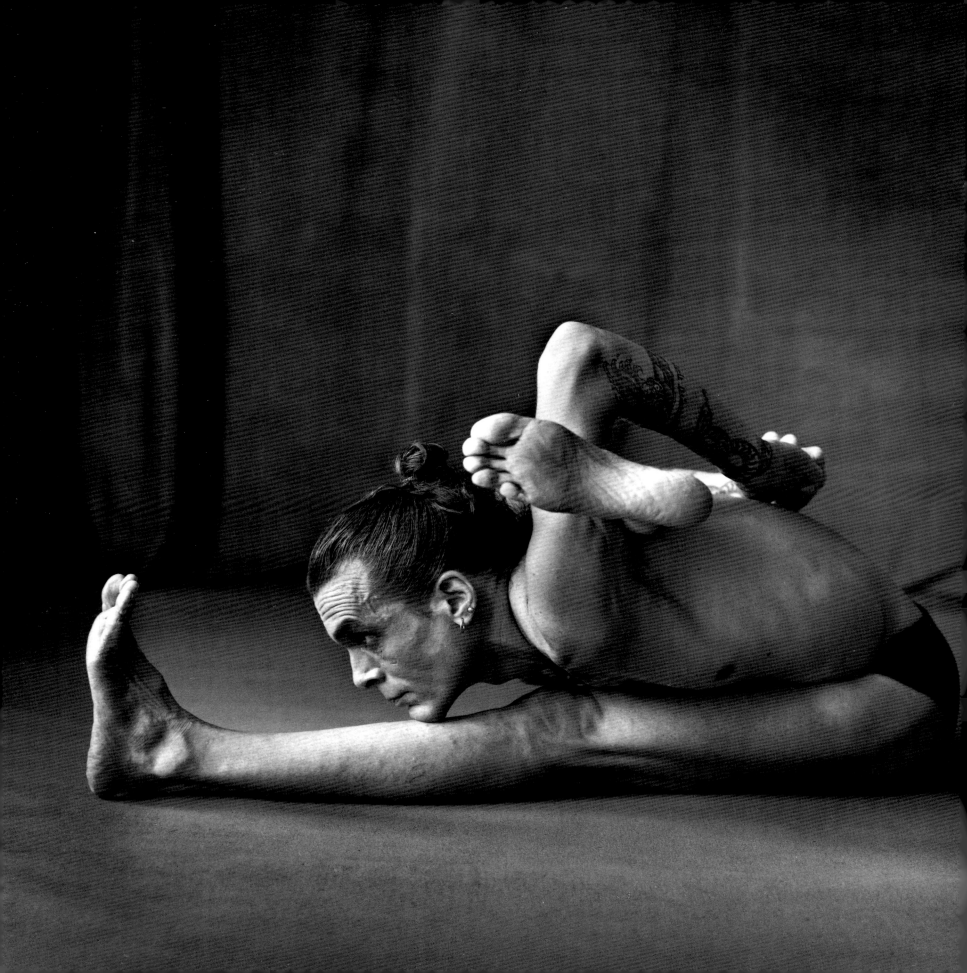

Certain bodily gestures are ritualized movements, such as bowing down, kneeling, or crossing the legs when seated. These gestures are imbued with volumes of meanings. The body has a language that is often unconscious. When ritual movement is given direct attention it becomes a powerful manifestation of the energy of nature. When we join the energy of consciousness with the energy of nature, we experience wholeness.

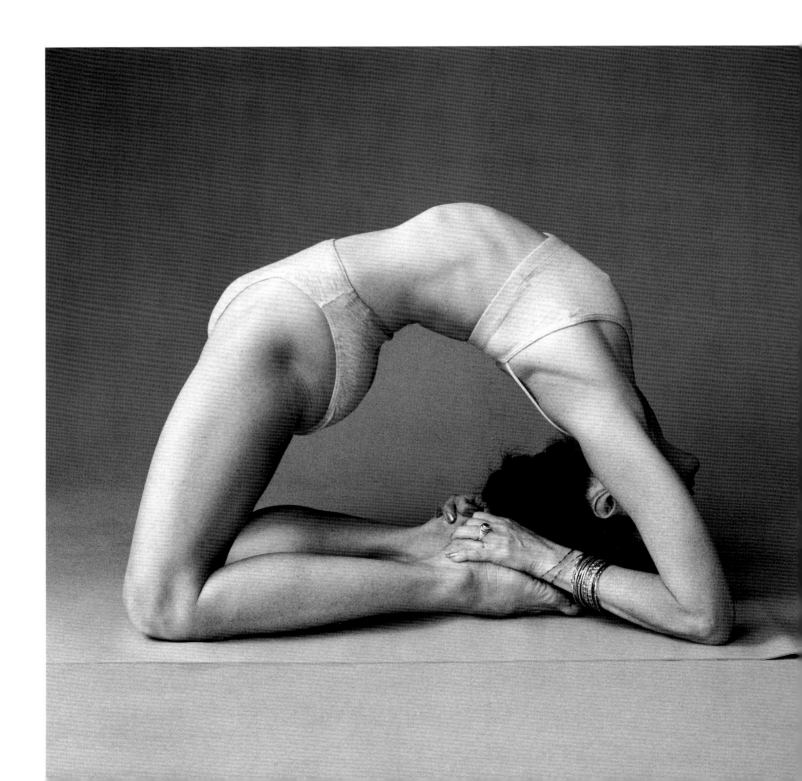

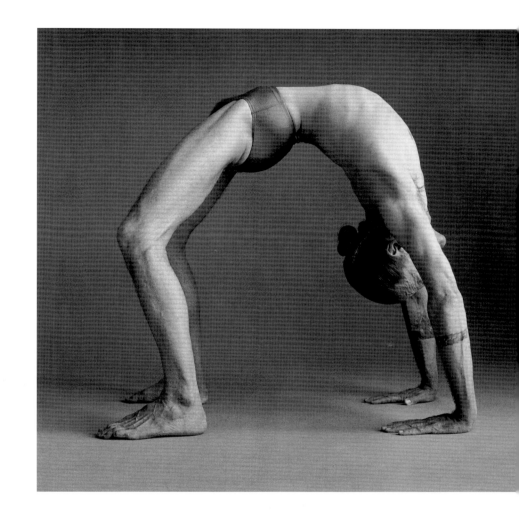

Bending backward is practice for moving into the future, fearlessly and gracefully.

The conscious mind has two primary states. It is either concentrated or distracted and cannot be both simultaneously.

Modern life creates distraction. The capacity for extended concentration is reduced. Creative people, original thinkers, and yogis must constantly sharpen the ability to concentrate single-pointedly.

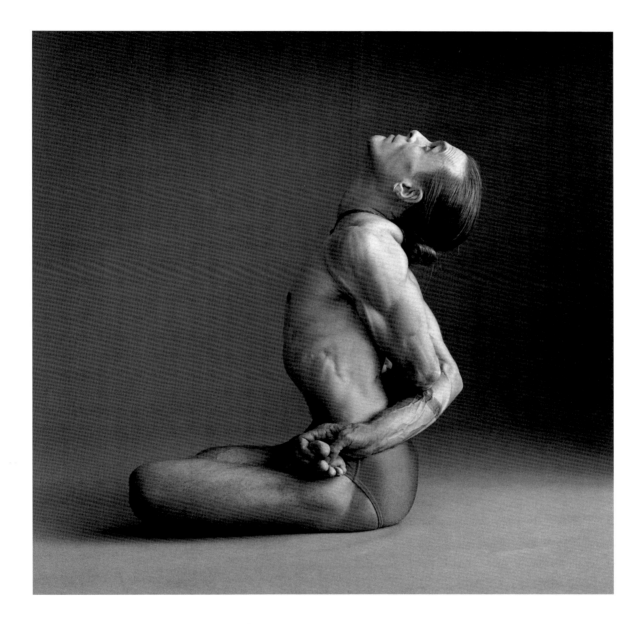

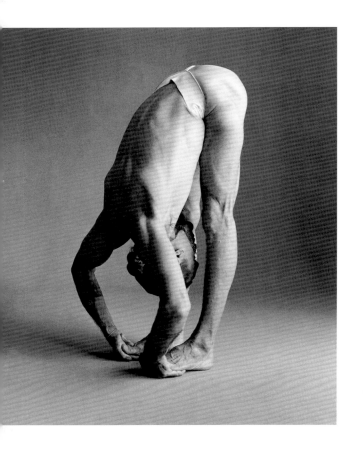

Asanas are a microcosm of life. They are minia-ture worlds filled with all the forms of the world at large. Our ability to thrive amidst those forms can be improved through the art-ful awareness developed in yoga practice.

Ruchikāsana

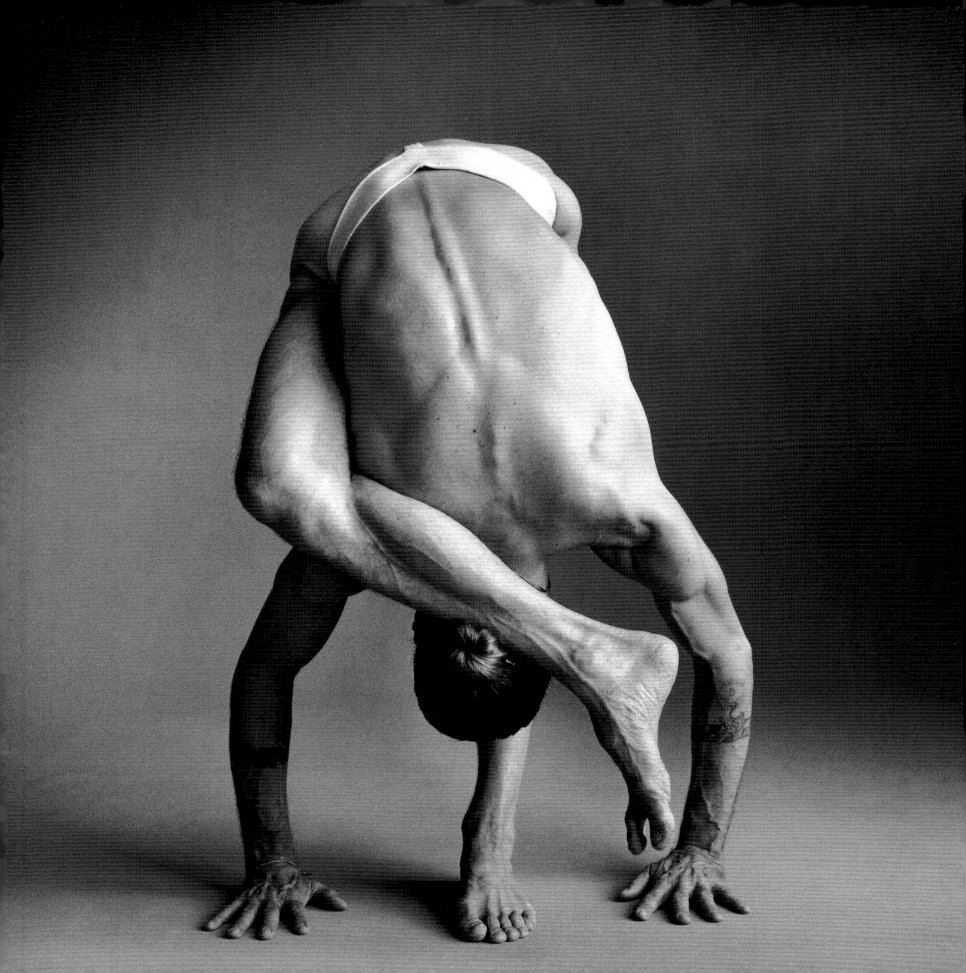

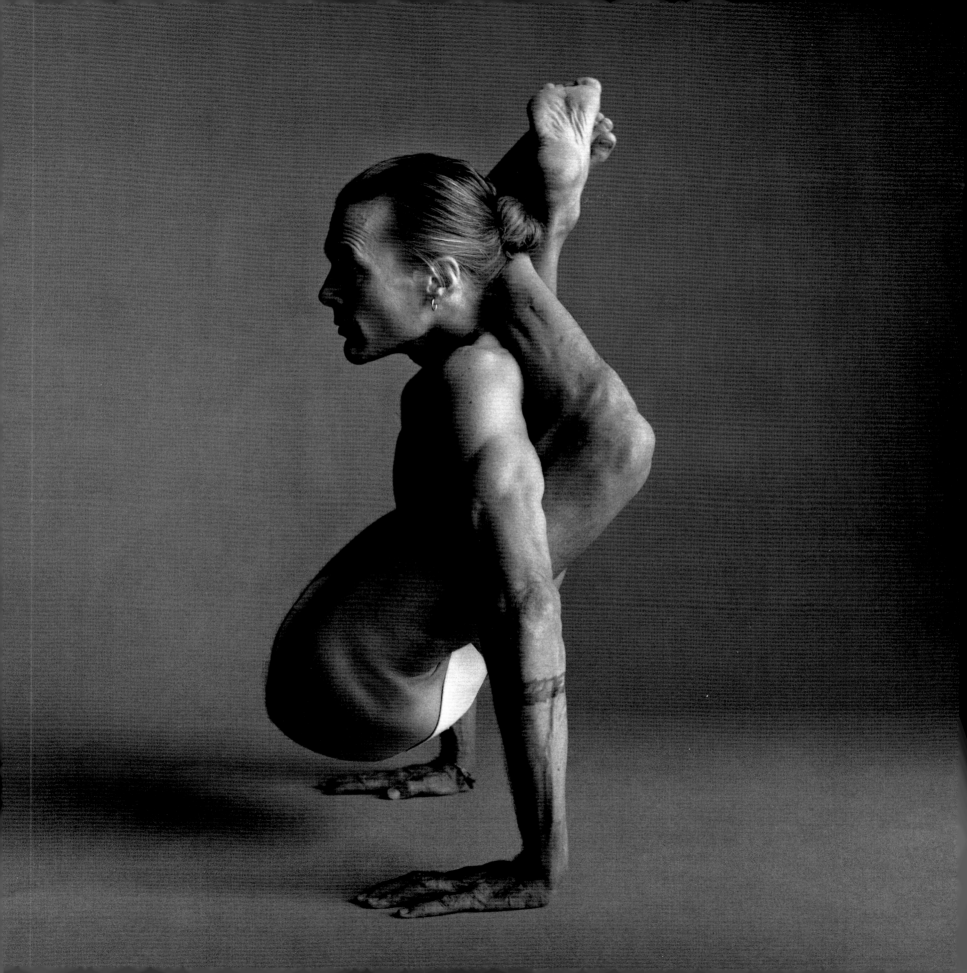

The mental intention underlying an action is always more important than the action itself. Our reality is manifested from our thoughts. As we think, so we will become. Any action is potentially liberating or binding depending on the intention.

Uttānāsana

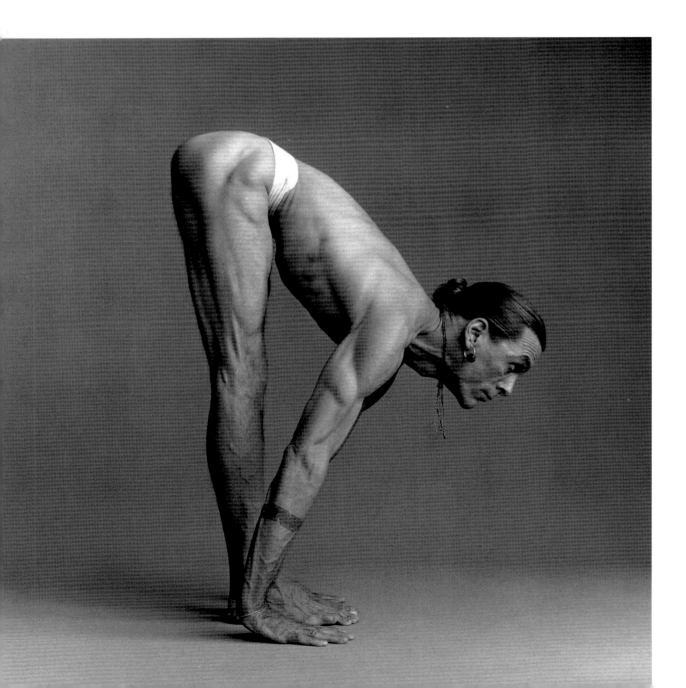

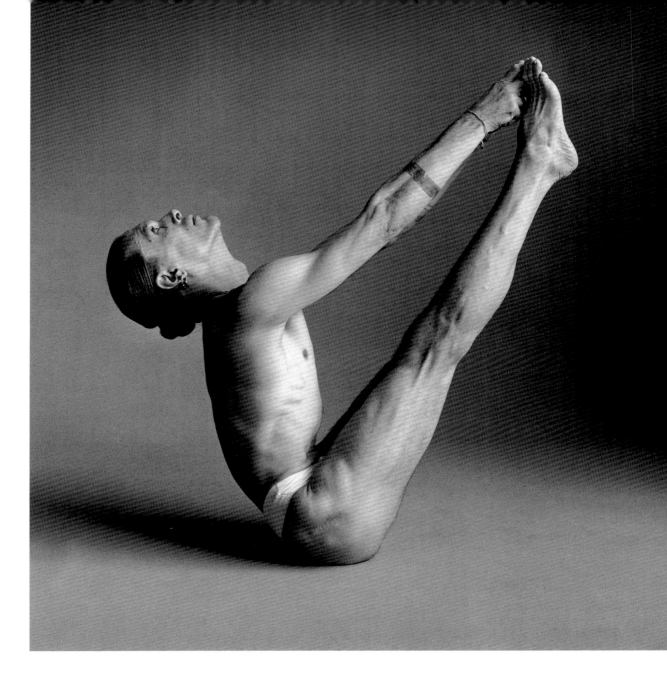

Set your sights on the Divine and your body will fall into
the most efficient alignment to receive the grace of God.
Eventually, complete transformation will arise.

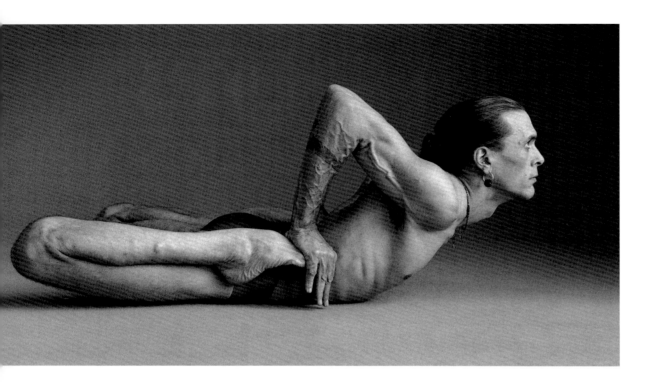

Many of the asanas take the form of archetypal figures. These are character-izations that embody the refined set of attributes which give each figure its potency and viability. When we apply those attributes directly to our own lives we bring power and potency to our quest. The archetypes are goddess, warrior, sage, magician, lover, child, snake, turtle, eagle, frog, lion, and more. Each shape of the body resonates with the essence of the archetype.

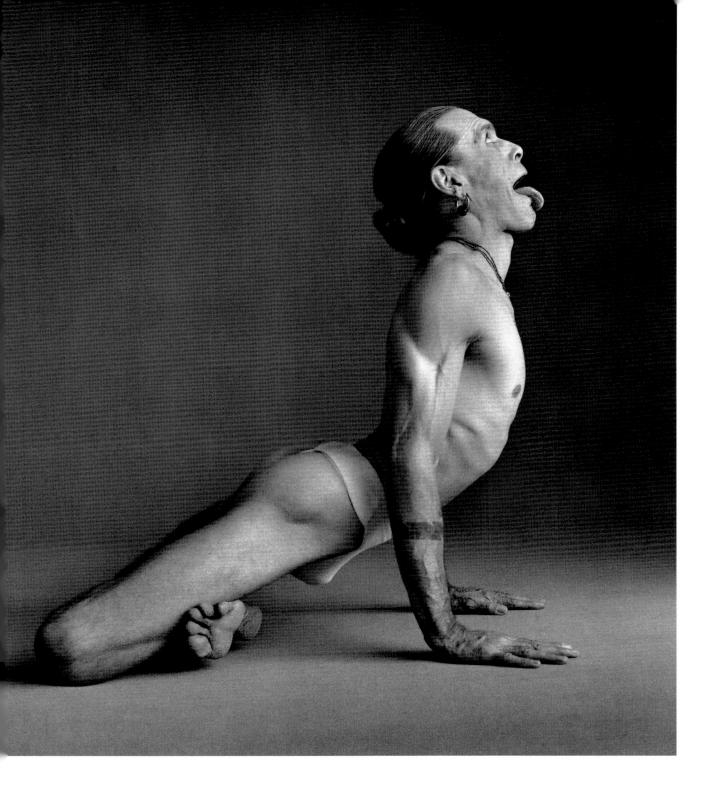

Padma Siṃhāsana

THE LOTUS LION

139

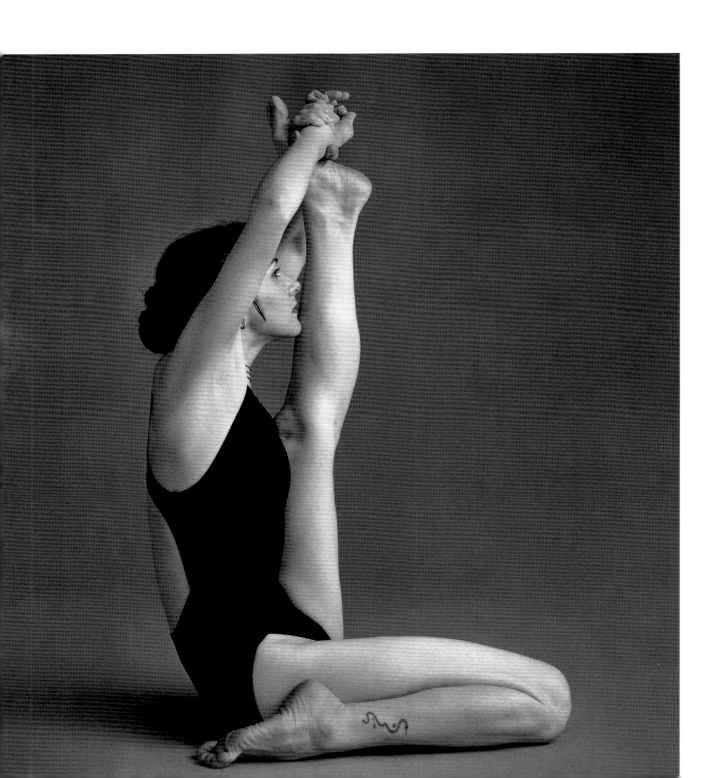

Krounchāsana
CRANE

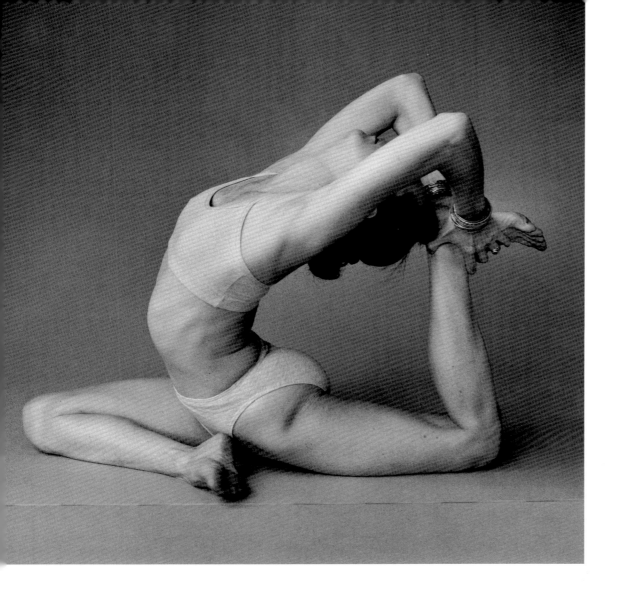

Rājañi Kapotāsana
QUEEN PIGEON

Make your body and mind into an inviting abode of
joy. Be patient, and receive the pulse of the spirit.

The lotus rises out of the mud unsoiled. The water drops of attachment roll off of its petals.

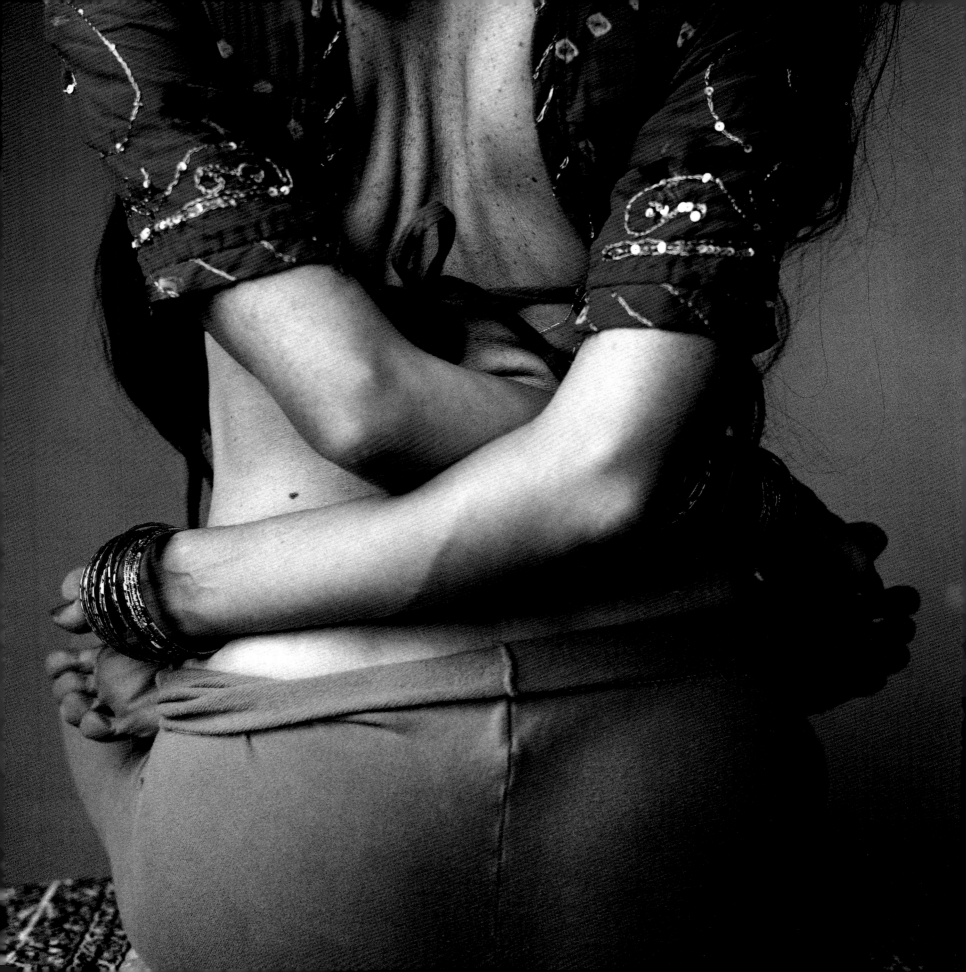

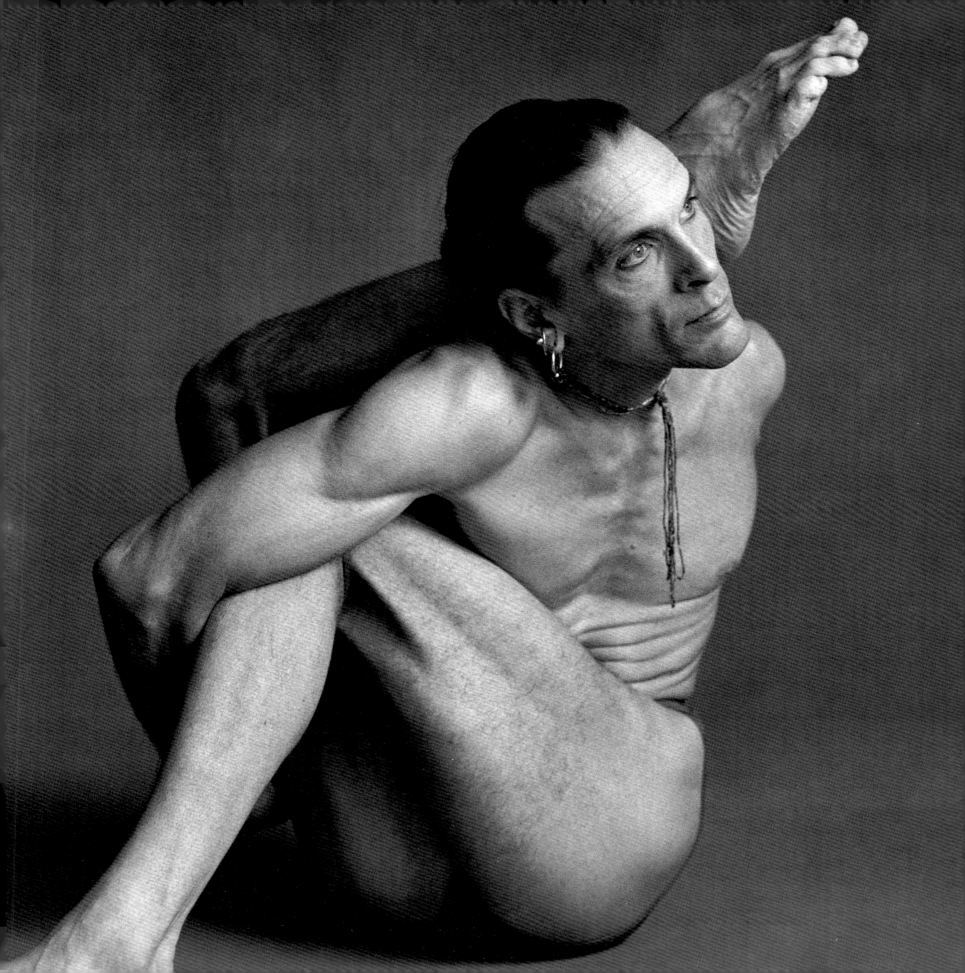

Bodily gestures stimulate changes in brain chemistry and electrical wave patterns. The yoga asanas are beneficial to the state of the practitioner's mind. These positions have been time-tested over thousands of years to yield the state of mind called *samadhi*, or bliss.

Fear of the unknown is the essence of fear. When nothing is unknown, there is nothing to fear. My guru told me, "Die today, and live the rest of your life free from the fear of death." When fear is no longer our primary motivation, good works become possible. In good works we find liberation from separateness, which is a disease of the soul. Facing the unknown, the yogi sees only the Self.

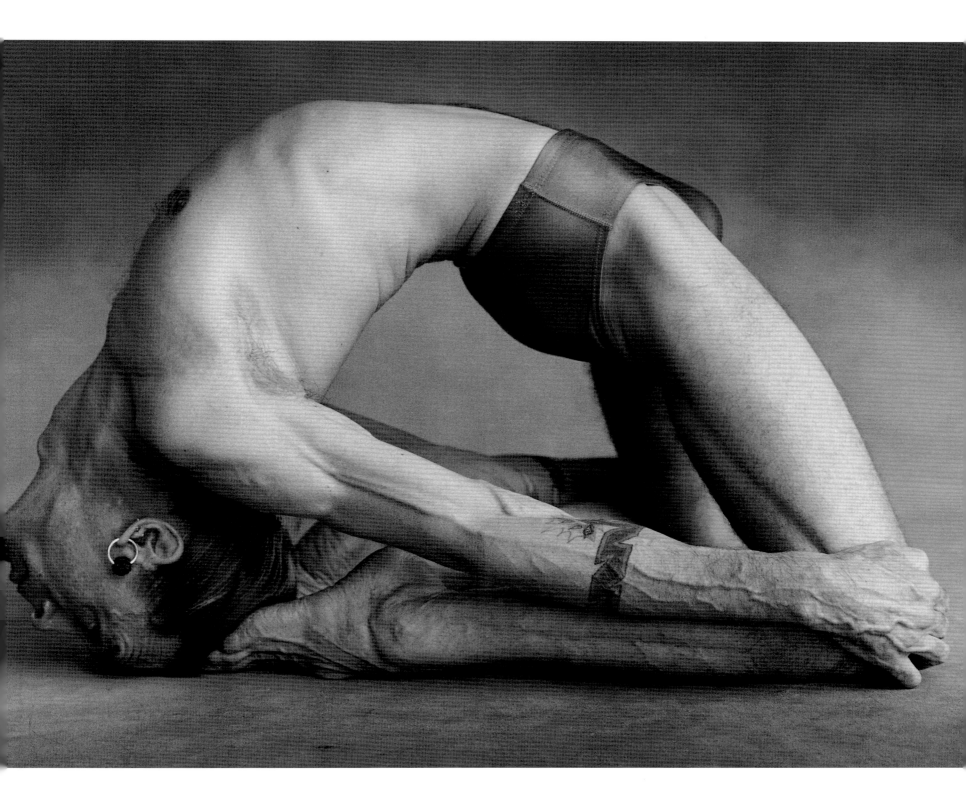

Bhekāsana

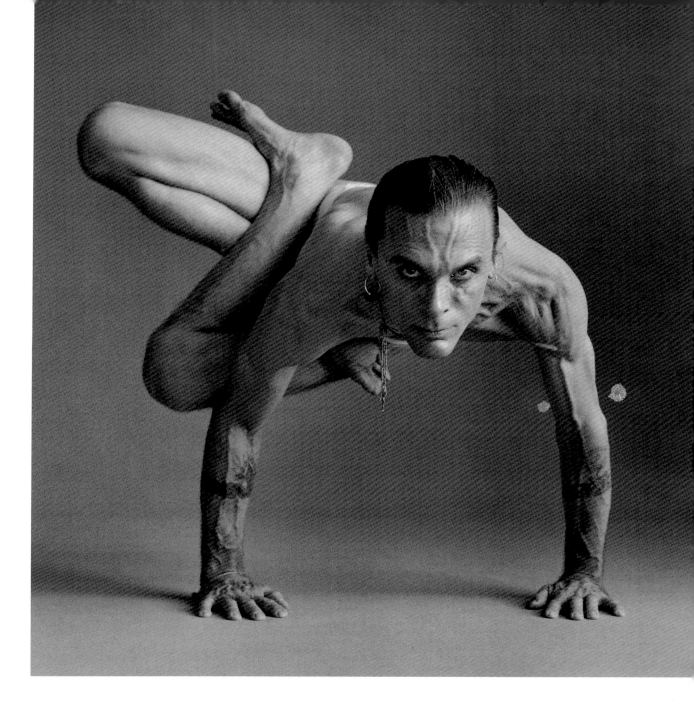

Pārśva Kukkuṭāsana

Karma is cause and effect; action and reaction. The structure of the human body is anatomical and precise. It is shaped by karma, by actions in past or present lives. An action can be taken with conscious wisdom or unconscious ignorance. A perfect action is devoid of selfish motivation. Yoga practice is the perfection of action and the realization of perfect results.

Parivṛtta Pārśvakoṇāsana

150

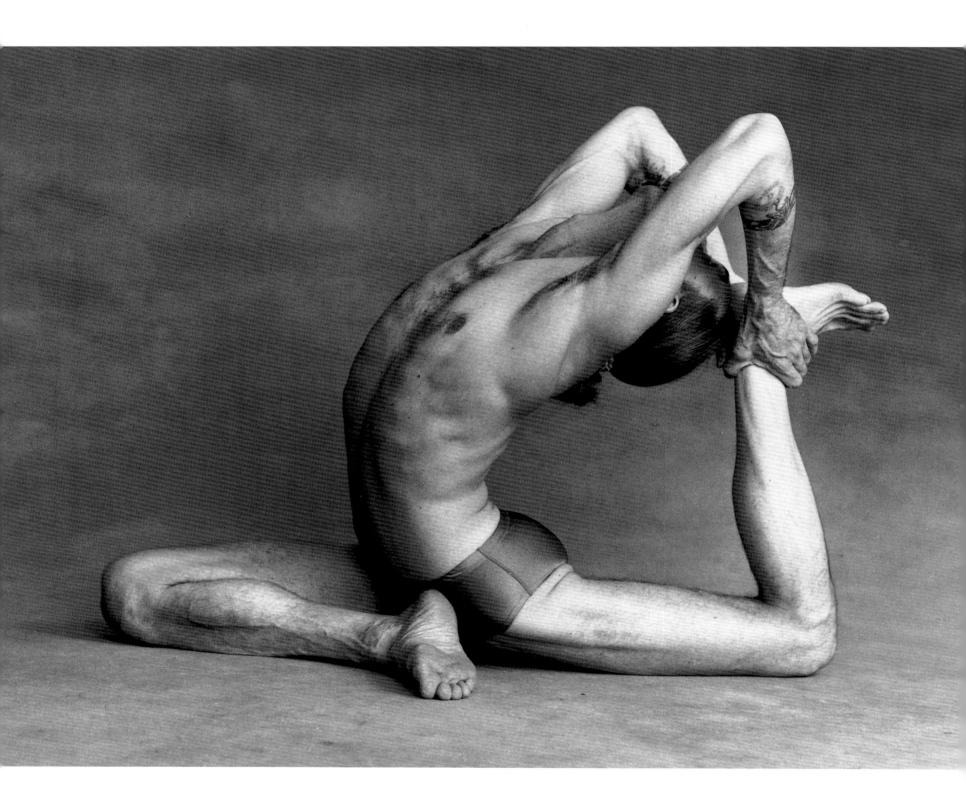

Each shape the body takes should conduct the intention from the heart to the universe. Yoga means experiencing directly without interference from the analyzing and associating tendencies of the mind. The source of all movement—indeed all life—is experienced directly. It is the experience of direct communication from the Source to the hand, and from the hand back to the Source, that results in the art of yoga.

The yogi shapes the body in ways that express a philosophy of life and existence where limitation is celebrated, ritual- ized, and penetrated.

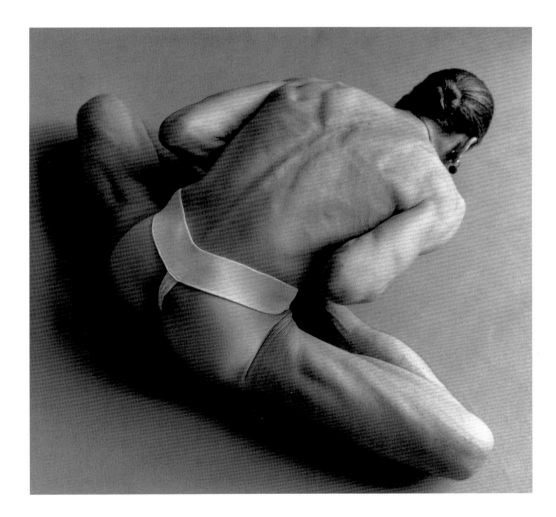

Yogaś-citta-vṛtti-nirodhaḥ

—Yoga Sūtra I.2

Yoga is attained when one ceases to identify with the movements of the mind, and identifies with the Self beyond the body and mind

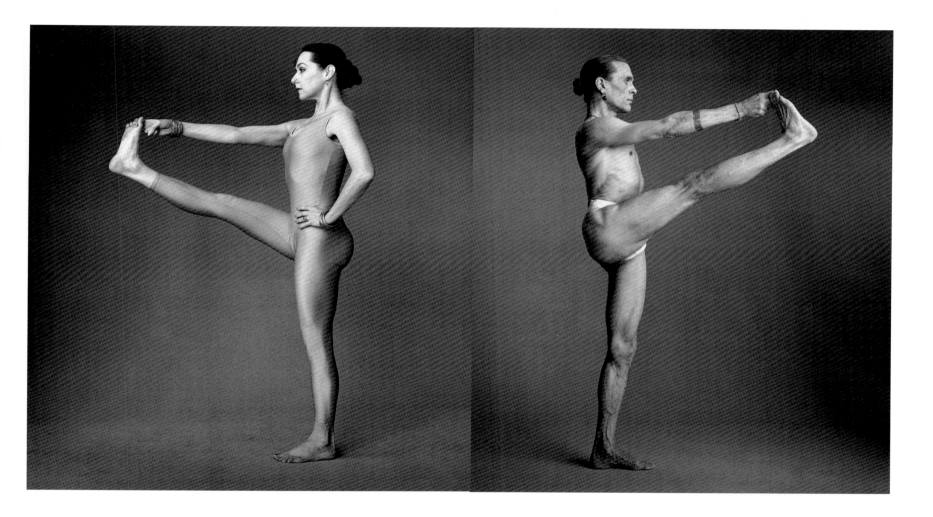

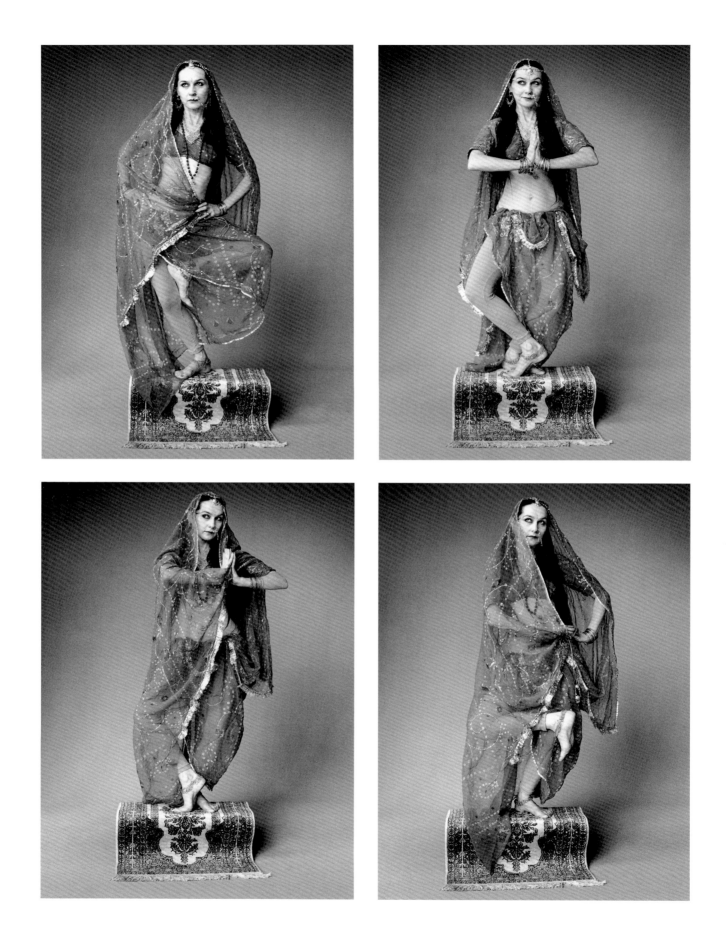

If the flute is clogged,
no music can be played.
When it is empty,
beautiful music can
come through it.

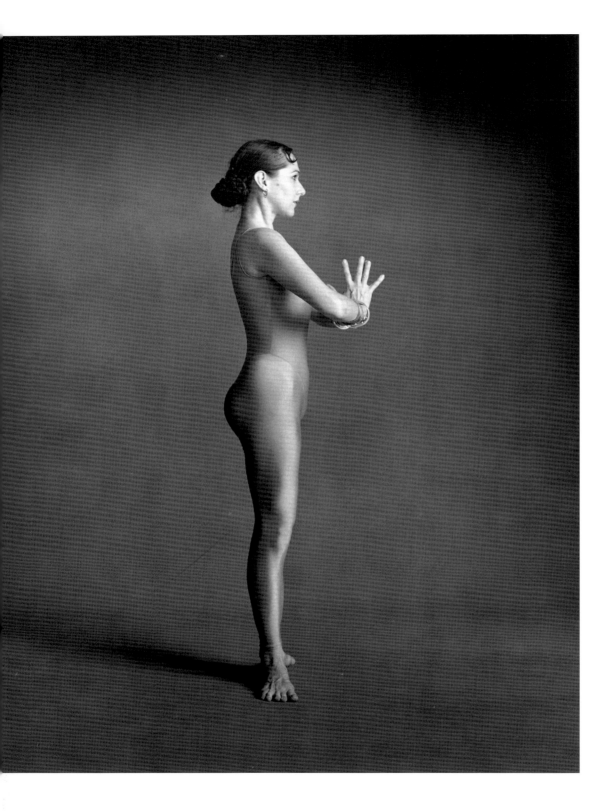

When we are filled up with everything we think we know, we are preventing any further learning.

Samakoṇāsana

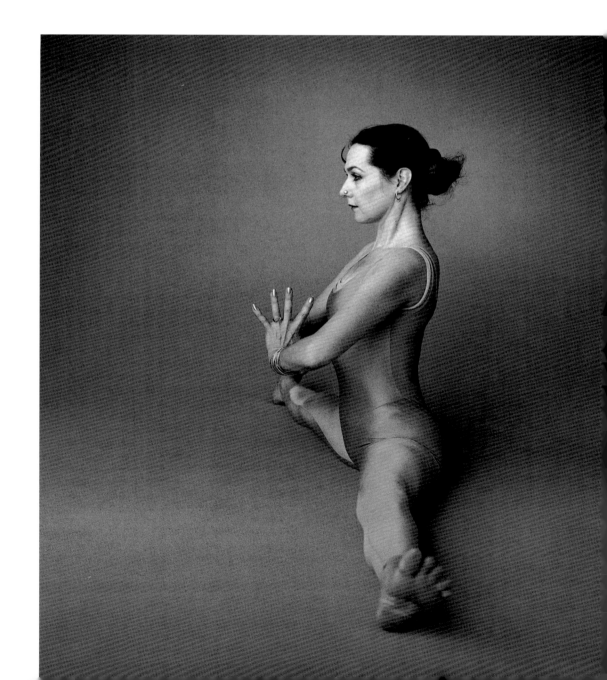

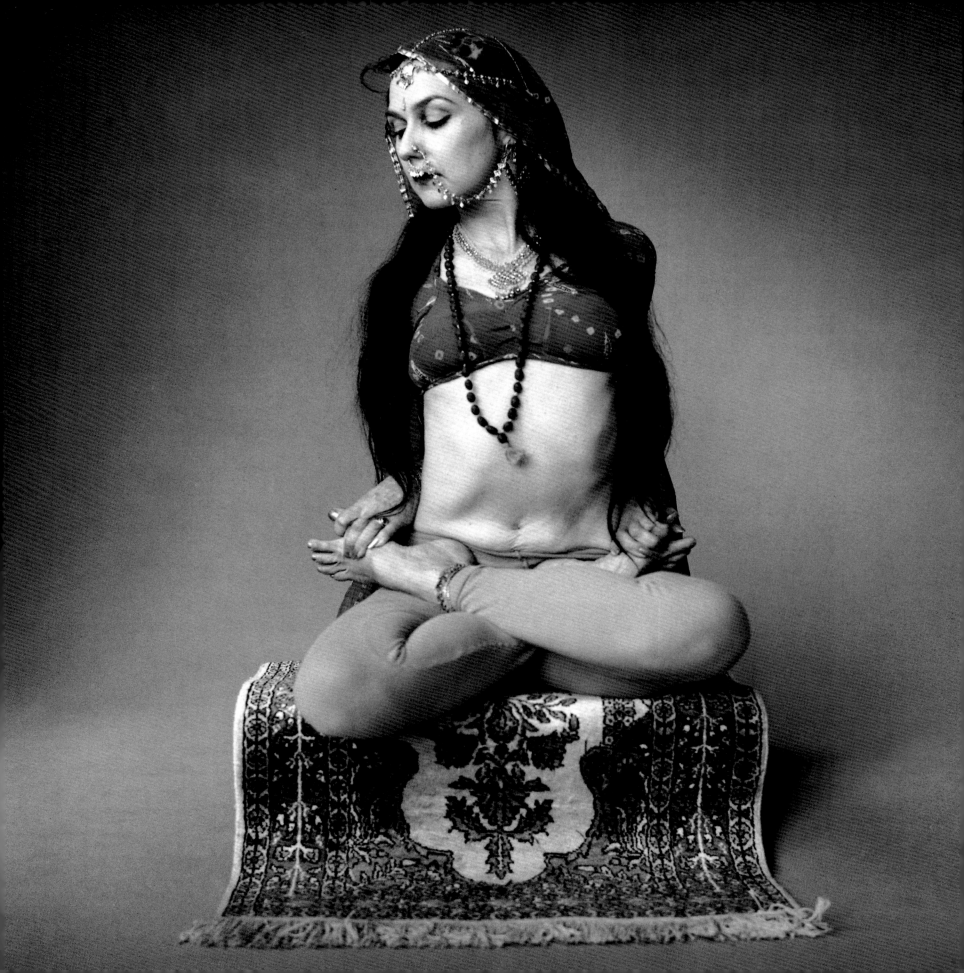

We must recognize our original nature as the bliss we feel at times, and pursue that bliss with single-pointed focus.

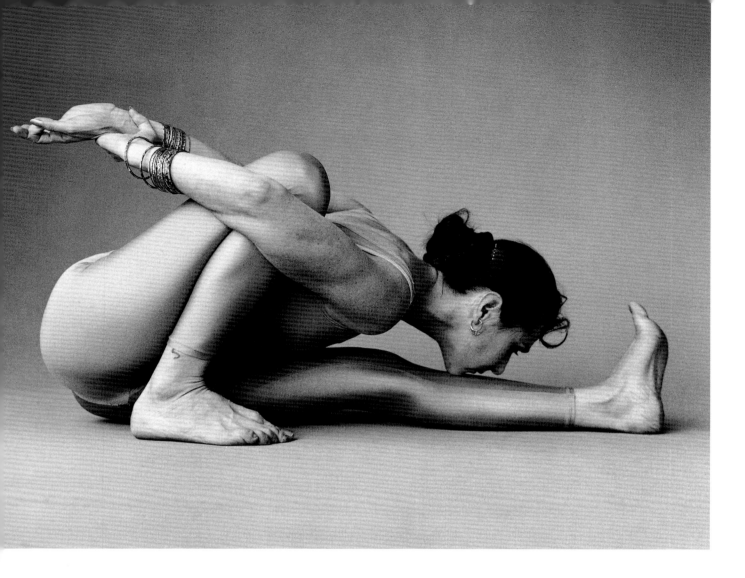

Marichyāsana

Become a vegetarian to minimize the harm you
cause others and find freedom in this very life.
What you do will come back to you.

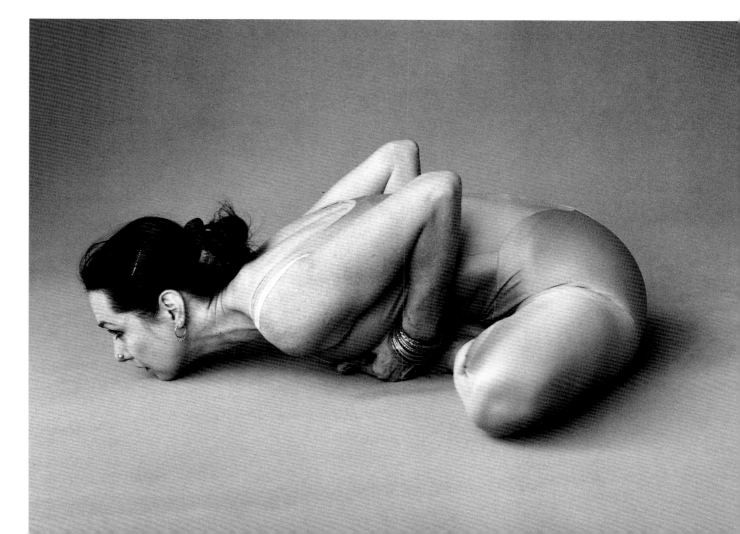

Baddhakoṇāsana

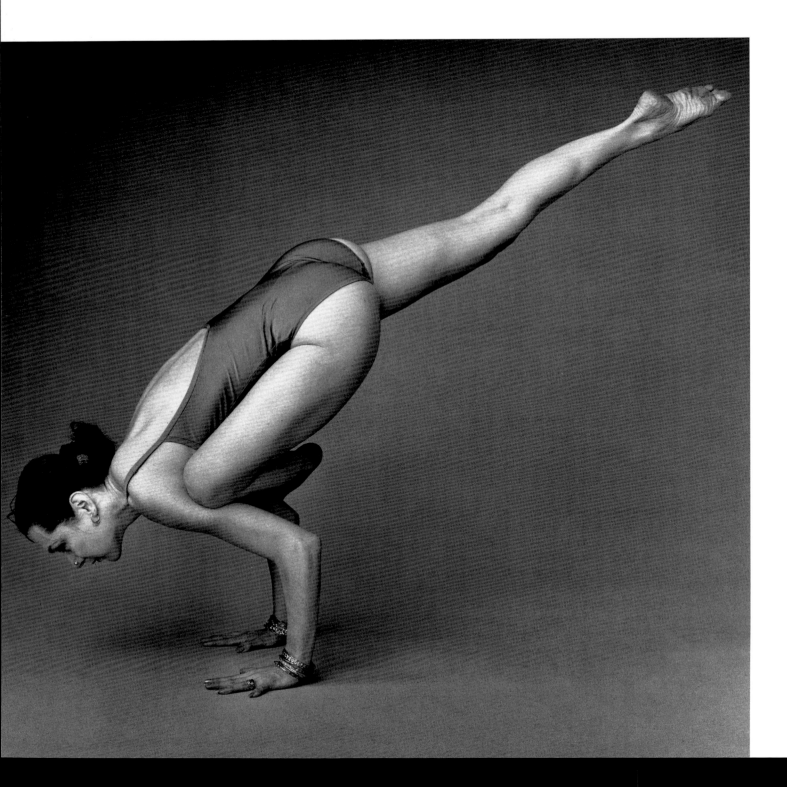

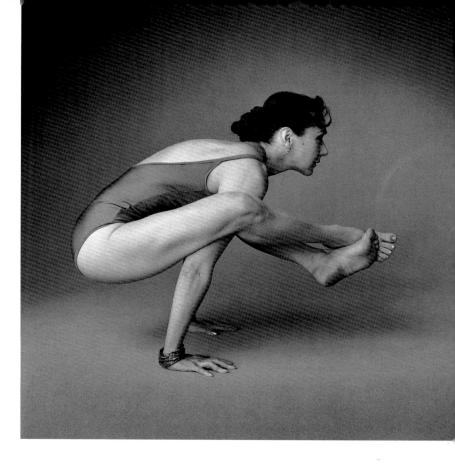

Bhujapīdāsana

By immersing ourselves in a daily practice with a routine that does not indulge in the ups and downs of the mind and body, we can create a habit of not giving in to defeat. If we develop a strong connection to a single-pointed intention rather than to the fluctuating mind, we have a platform from which to launch ourselves fearlessly into Selfhood.

If we give our energy over to our problems, they grow larger and maintain their prominence in our experience.

The major problems in a person's life are usually never solved through thinking. When you are able to elevate your mind beyond your thoughts, a solution will be evident.

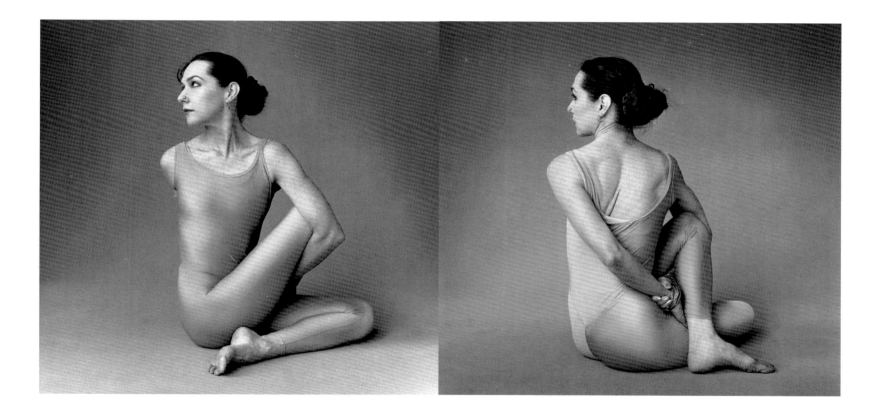

You cannot "do" yoga. Yoga is your natural state. What you can do are yoga exercises, which may reveal to you where you are resisting your natural state. What is this natural state? Eternal everlasting happiness: Bliss.

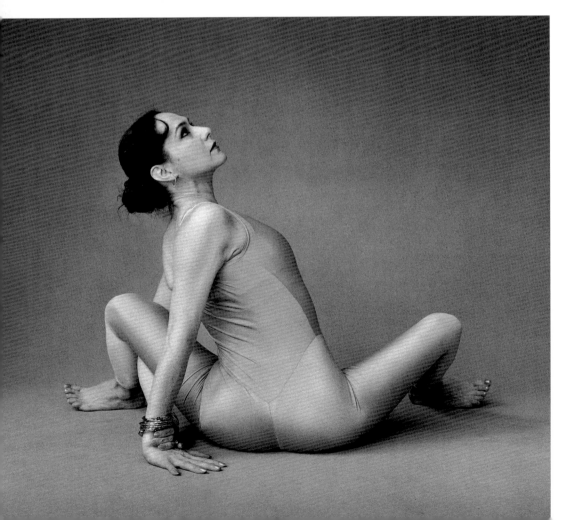

Parīvṛtta Vikāsitakamalāsana

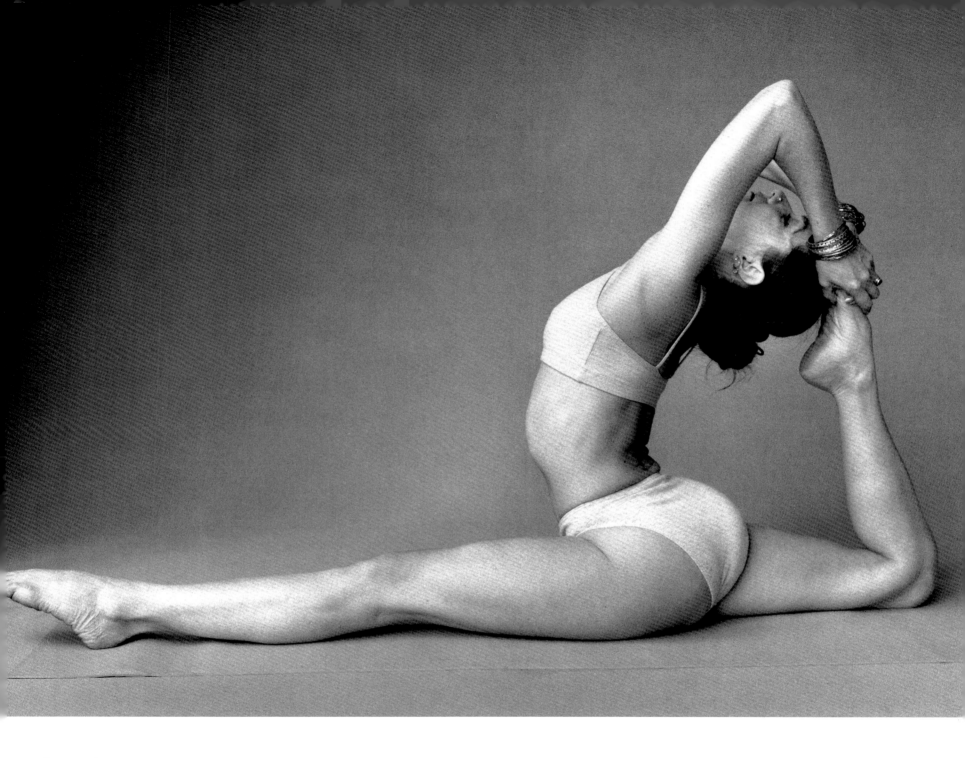

Eka Pāda Rājanikapotāsana

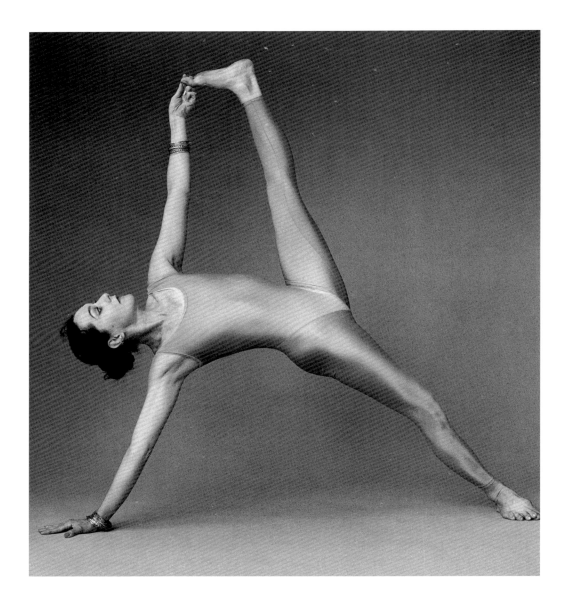

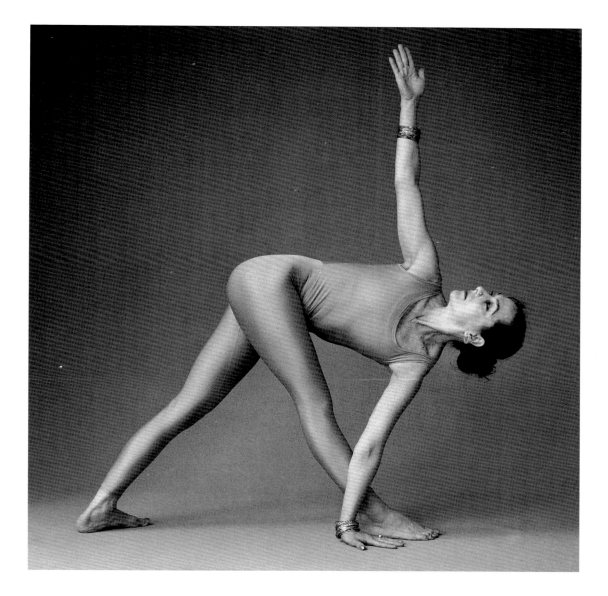

Let your desire to serve God overwhelm all other desires.

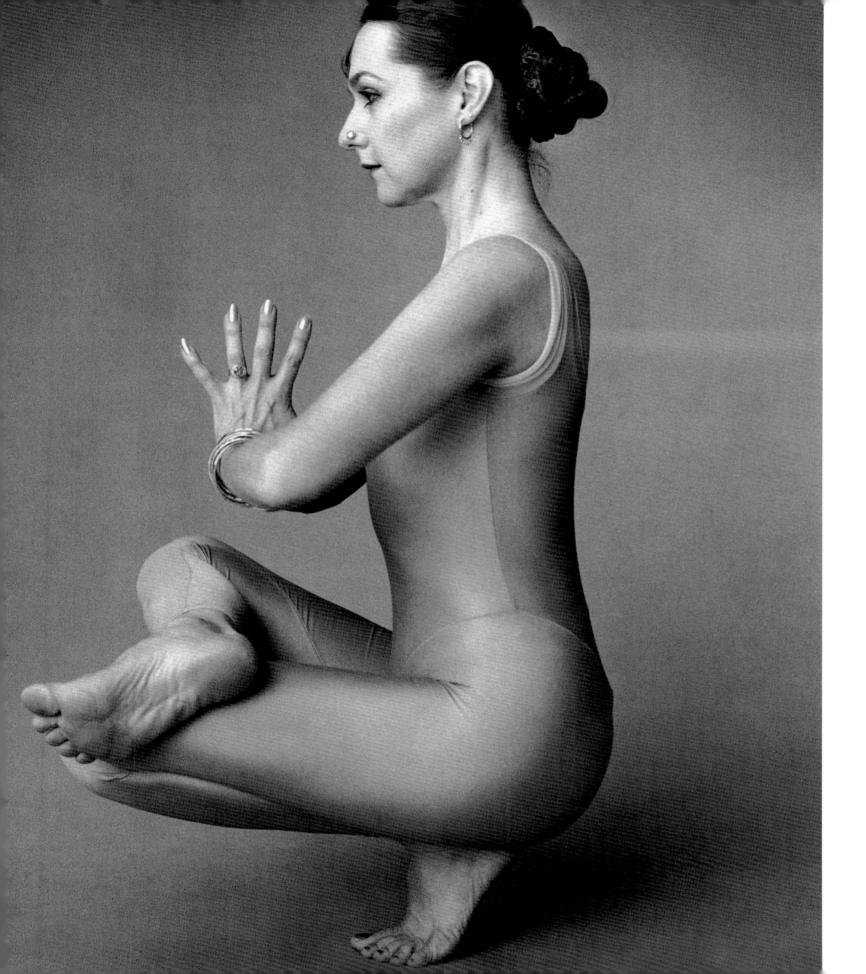

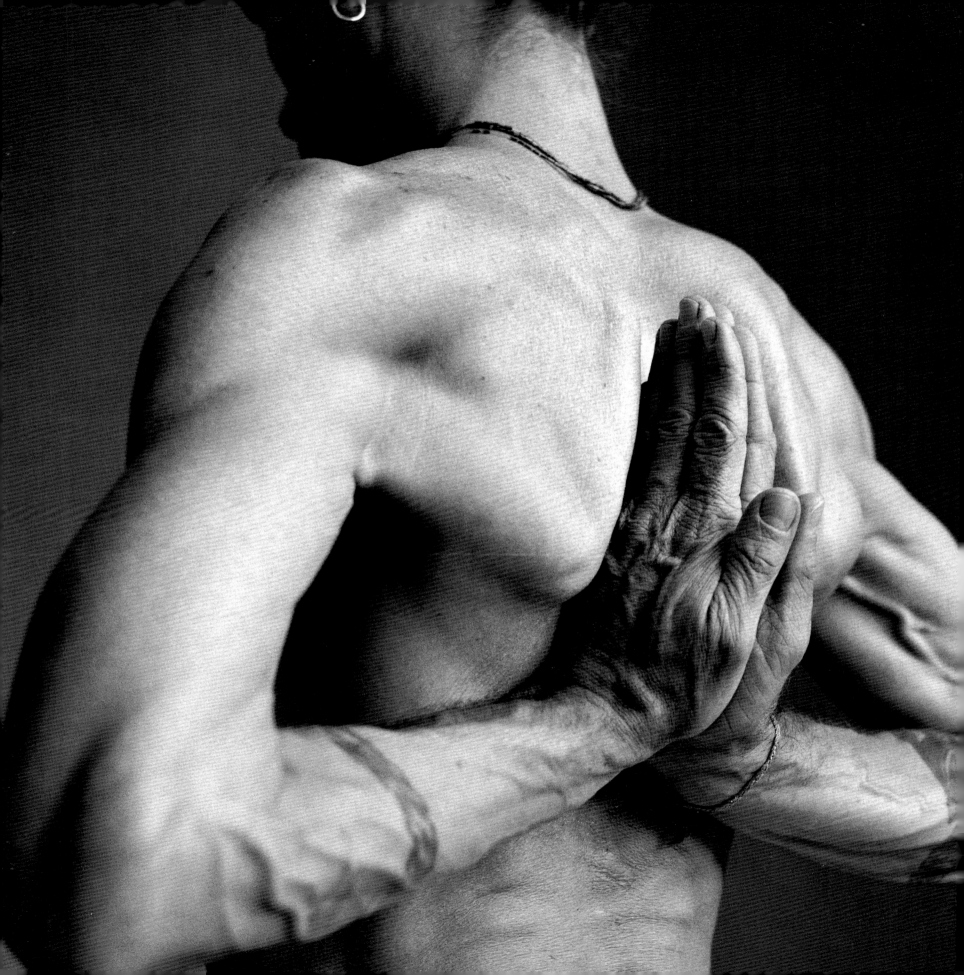

Aha! is the exclamation of discovery, the sound made when something that has been lost is found, an expression of recognition and reconnection. The first letter in the language of yoga, the Sanskrit alphabet, is Ah and the last letter is Ha. The yogi endeavors to experience the beginning and the end simultaneously in the present moment. The beginning is also the end. The way in is the way out.

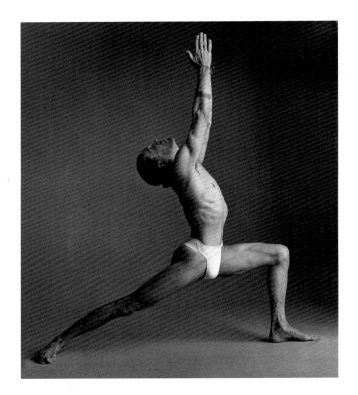

Vīrabhadrāsana II

WARRIOR TWO

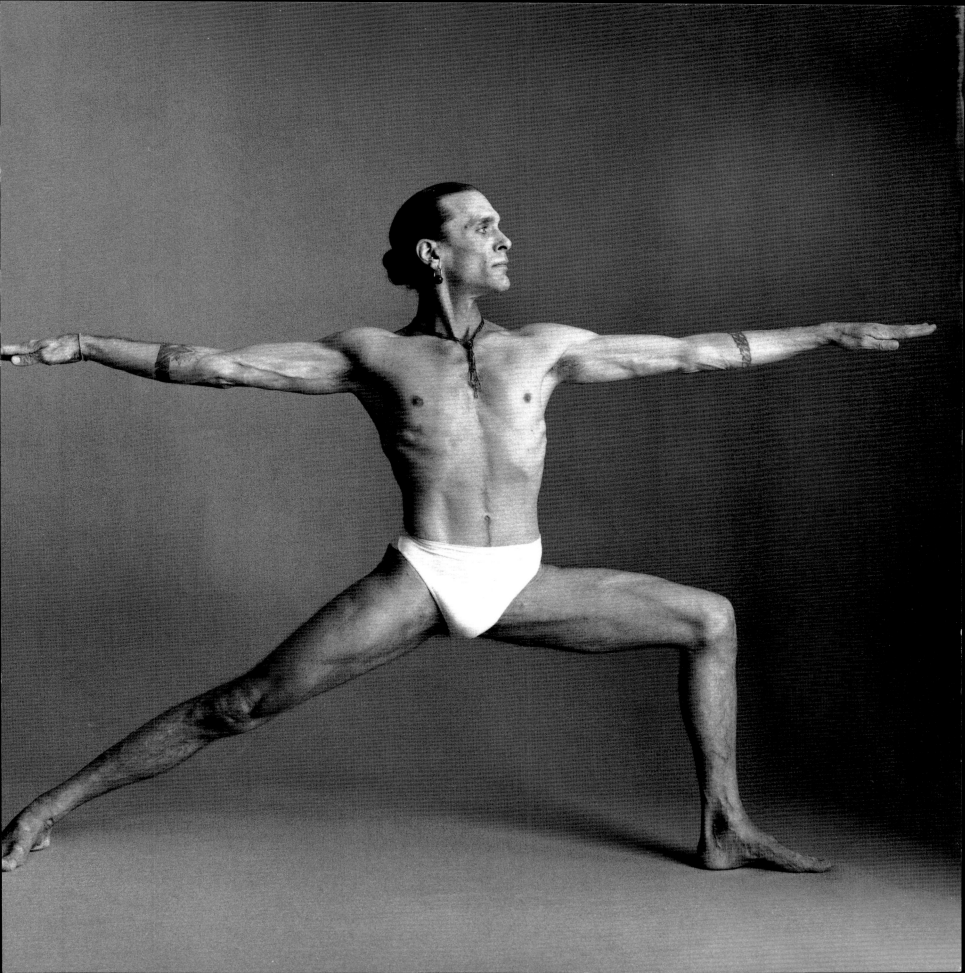

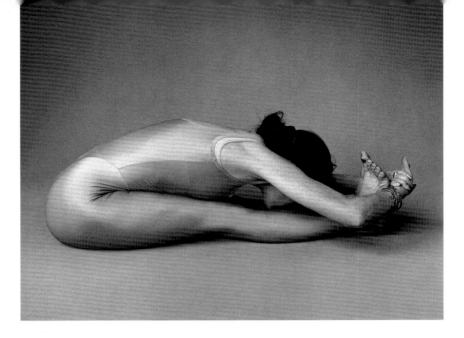

We can become stuck in habits of selfishness.

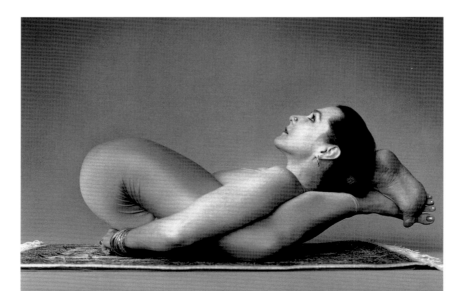

The yoga asanas help us to overcome these habits by making us aware of them. When you practice asanas you feel your resistance to joy as tightness and pain in the body and fear in the mind. These feelings reflect your tendencies to anger, greed, jealousy, and sadness. Through this awareness you can begin to let go of these negative habits that distance us from joy.

To move into all possibilities

with ease—cultivate joy.

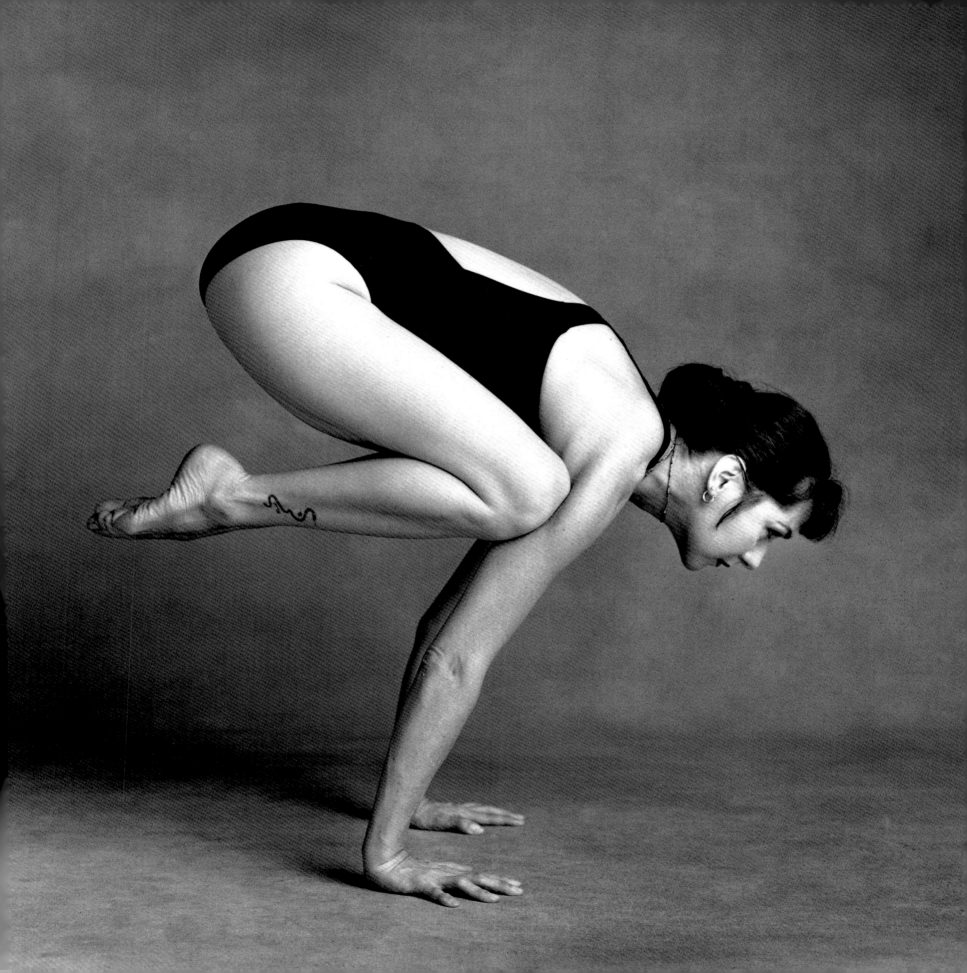

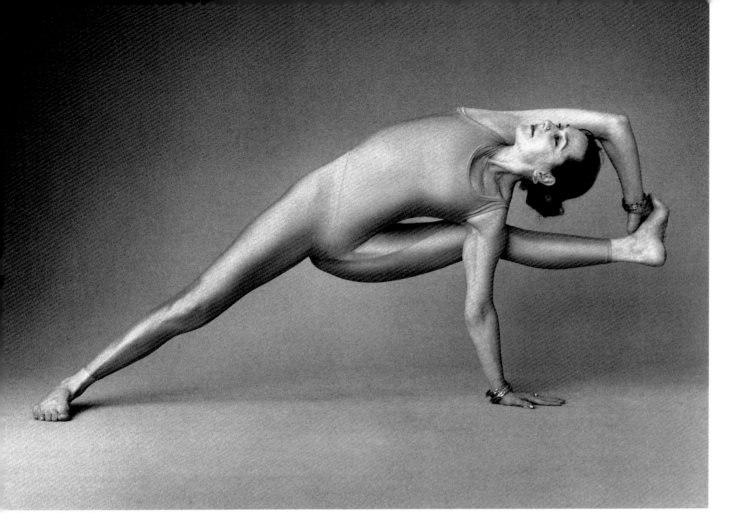

Viśvāmitrāsana

The breath.

It's just like life itself.

It comes and it goes.

Koṇāsana

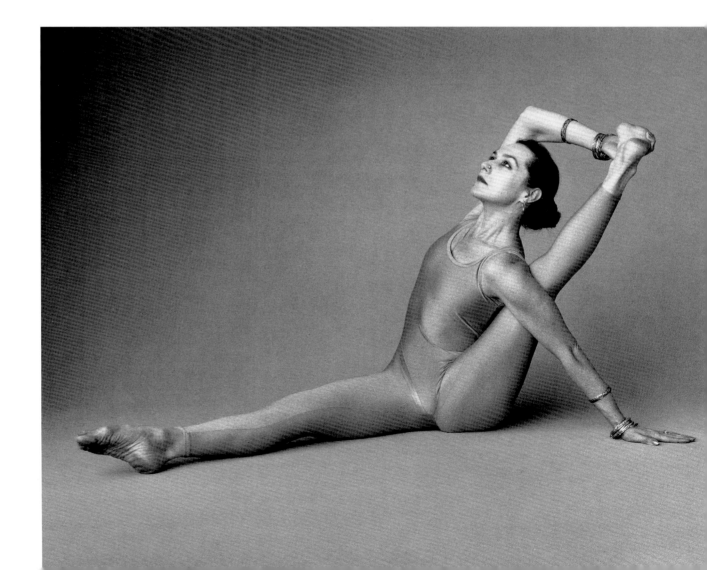

Most everything we experience through the five senses is a trick, a projection of what we want or need to experience. Yogic vision goes beyond the limits of normal senses to an inner essence that is always true, no matter how the appearance changes. Yogis develop x-ray vision.

Don't hold back. Give your all to the Divine Will.

Allow the spirit to inform your body and mind.

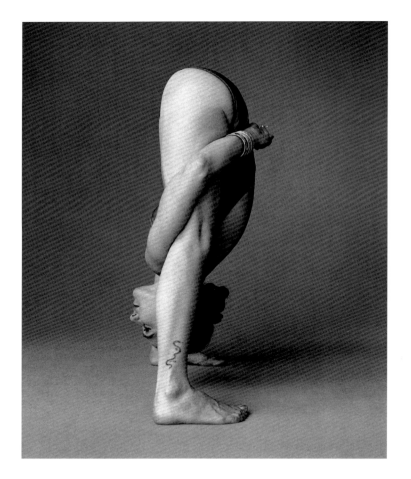

Tittibhāsana

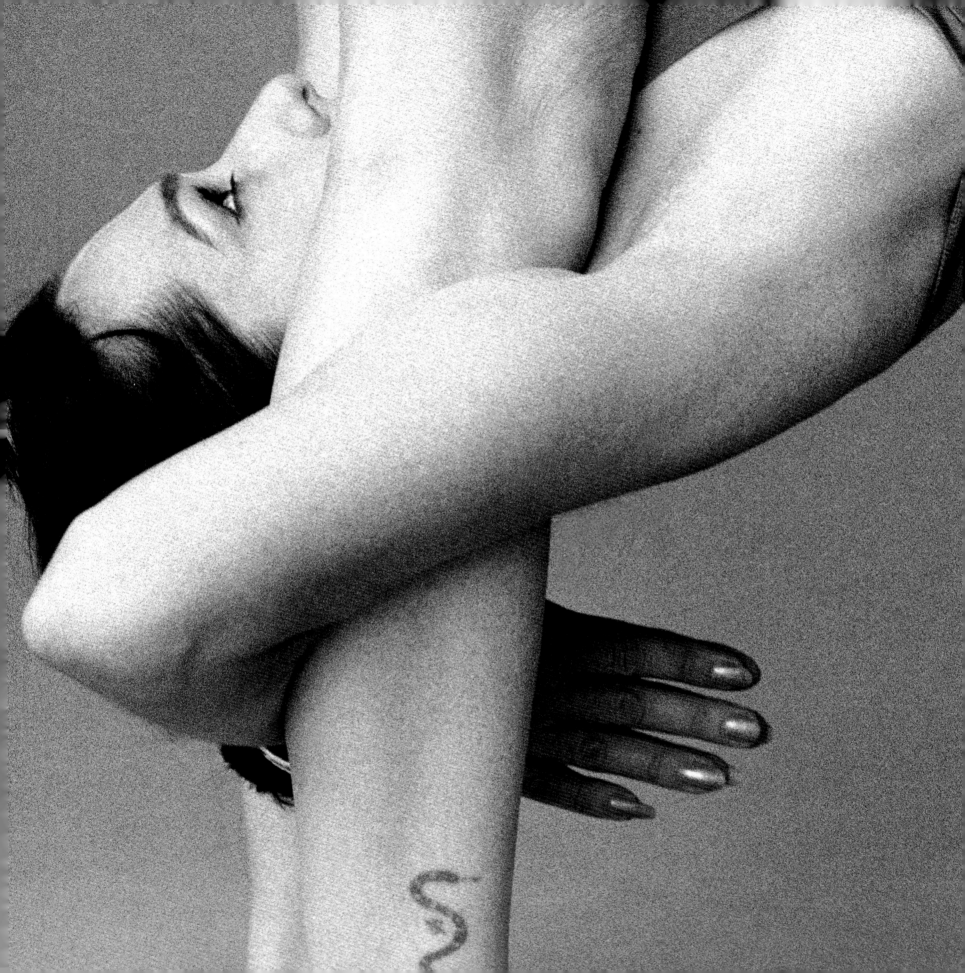

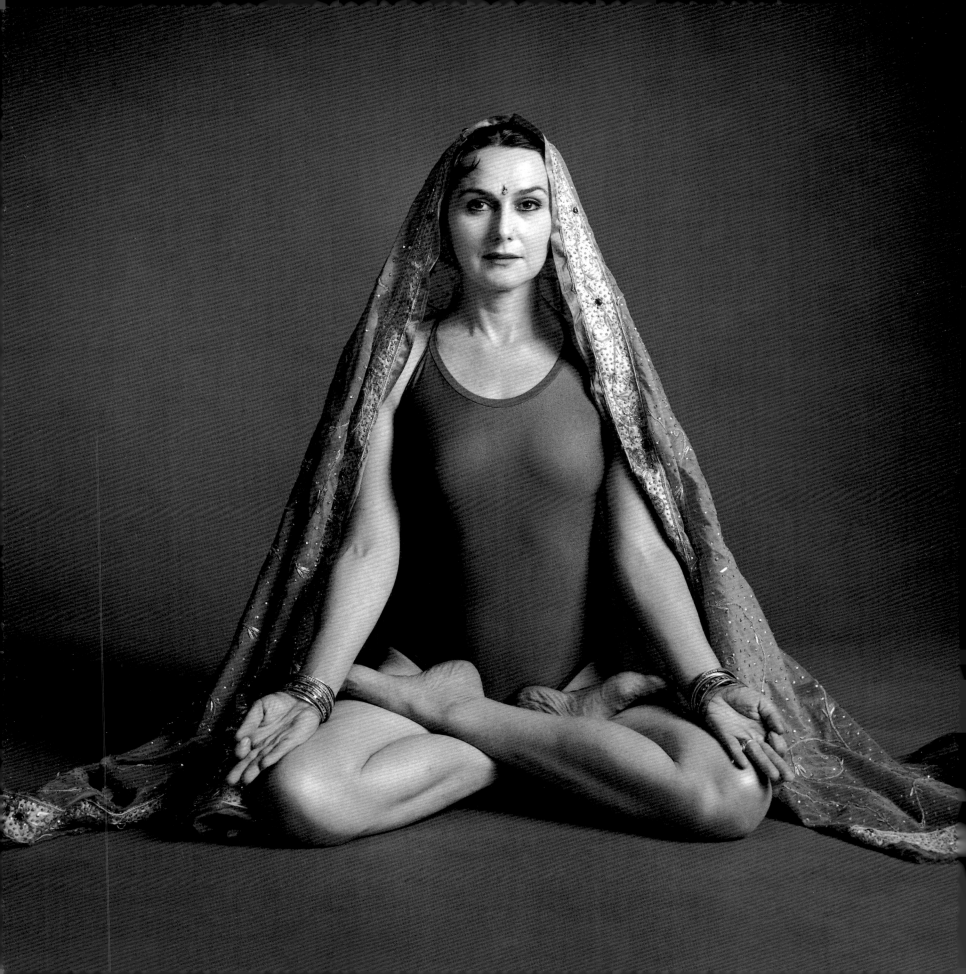

The goal of yoga practice is *samadhi*. Samadhi is the solution or completion. It is the end of questions and answers: a conditionless condition in which there are neither problems nor solutions.

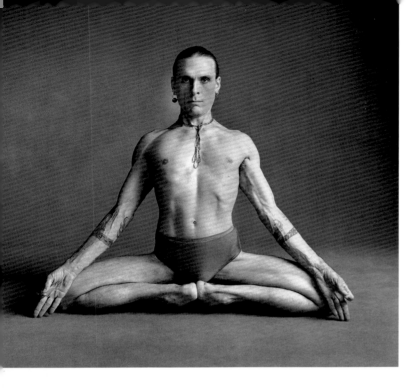

Mūlabandhāsana

Acknowledgments

We would like to acknowledge the following people
who helped to make this book possible:
Our editor Marisa Bulzone and her production staff
at Stewart, Tabori, and Chang: Pamela Schechter,
Director of Production; Nina Barnett, Senior Designer;
and Elaine Schiebel, Assistant Editor.

Assistants to Sharon and David: Amy Gail, Andrea Boyd
Make-up and hair: Tracie Martyn, Leanne Hirsh
Costumes and styling: Pilar Limosner
Mehendi: Stephanie Rudloe
Tattoos: Vyvyn LaZonga, Michelle Edge
Early text revisions: Jenny Meyer
We also thank Gil Freisen, Janet Rienstra, Trudie Styler,
Sukanya Shankar, Barbara Boris, and Patti Katchur @ 68 Degrees Lab
for the roles they played in pulling this book together.